How to Make Your Food Famous

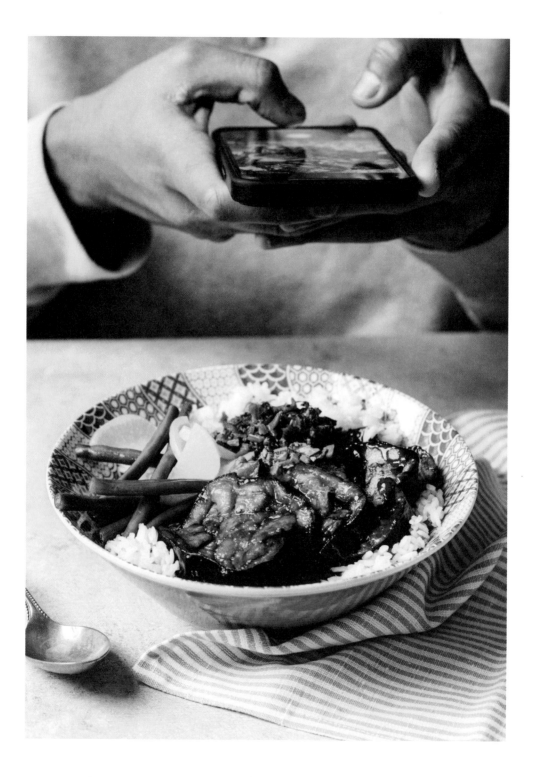

How to Make Your Food Famous

A masterclass in sharing your food online

Kimberly Espinel

WHITE LION PUBLISHING

Contents

INTRODUCTION

If you're reading this book, it's probably because food means everything to you. After all, food is at the heart of most things we do – it symbolizes breaking bread with the people you care about the most, it means happy memories. How could you NOT want to share all that with the world?

It is for this precise reason that during lockdown in 2020 there was a surge of new food creators who provided entertainment, education and comfort; their online presence was, and still is, absolutely invaluable. As a result, food influencers and food content creators – terms I use interchangeably in the book – became the rock stars of our time. Yet, just like the rock stars from days gone by, they are often dismissed as untrained, unprofessional, and therefore less worthy than classically trained chefs. Or worse, they are seen as fame hungry and always pushing a sale. Yet anyone who seriously thinks this about food content creators hasn't the faintest idea what it really takes to grow an audience online. It takes recipe development skills, camera and editing know-how, script-writing and marketing competency, excellent communication abilities and a deep understanding of social media. Moreover, it takes hard work, determination, passion and, above all, unwavering commitment.

Maybe you believe you've missed the boat on Instagram and TikTok, that it's too crowded for yet another creator to get noticed. Or you feel a little silly for wanting to become 'food famous'. Please know that seeking fame for the thing

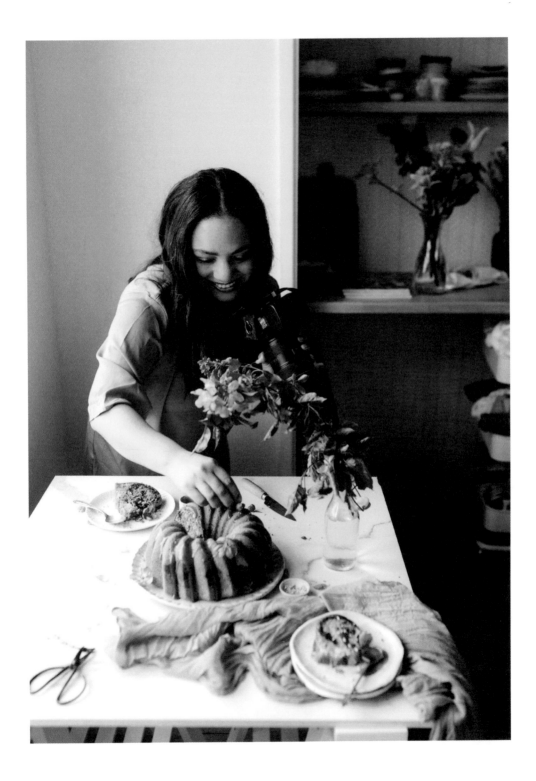

you love and obsess about the most isn't silly at all. It's brave, it's generous, it's vulnerable and it's honest. It's also rooted in an innately human desire to be seen for who you are as a creative being – and that's ok! My aim in this book is to show you that your dreams of creating your own food content and food-obsessed following, gaining recognition for your incredible recipes, and receiving praise for sharing delicious food stories and visuals is absolutely still possible. It's never too late to grow an online community who adore you and your food, and this book is the road map that will point you in the right direction and enable you to make it happen.

So how exactly can you develop all the skills needed to achieve and maintain food fame? What should you focus on first if the passion and commitment are already there, yet the online fame is eluding you? After spending months interviewing the best food influencers I could find, and years growing a sizeable audience of 140K+ on Instagram myself, I discovered that there isn't a one-size-fits-all way to grow your online community. There isn't a short cut, a hack or a trick that will get you there overnight. So if that's what you're looking for, please know that this book isn't for you. Instead, there are a variety of pathways that can lead to the top of the food pyramid. Plus, not only is there space for everyone, there's bound to be an approach in this book that's just right for you and your unique food stories.

This book consists of three different parts. Let's Get Technical, as the title suggests, is all about the technical side of sharing your food online – from sourcing the right gear, to lighting your food to perfection, editing like a pro, and many other practical tips and tricks to help get you started.

You'll also find the Creative Toolkit, where I delve into all that's needed to make it as an online food content creator beyond the technical: there are tips on monetizing your content, insights on how to style your food, guidance on finding your style and keeping it consistant, as well as proven approaches to tackling one of the biggest obstacles on a creator's road to food fame – procrastination! These sections tap into the creative, the emotional and the aspirational, to support you in the process of building an online community.

Lastly, there are interviews with over 40 of the best and brightest food content creators from around the world, all of whom have amassed a huge online audience. They know what it really takes to make your food famous and generously share their insights, tips, and tried-and-tested methods with you. The content in these sections is all about the practical and the inspirational, to help you find success in your own right.

Now, you might be wondering whether the tips shared by the content creators are unique to their situation – that perhaps they won't work for you as well? I wondered the same thing, so I took some of the insights shared in this book and put them to the test. Not only did I gain 15K followers on Instagram in the three months during which I implemented those tips, I also had my very first viral Reel and viral TikTok moment. In that same time frame, a further three content pieces went viral, despite me posting no more than three times a week. In short, it can be done, even if you're not a full-time content creator (yet).

In this book, I'll present you with lots of different versions of what food fame can look like and, more importantly, lots of different ways to achieve said fame. It's my hope that this volume will serve as a companion on your creative journey, as you navigate the best way to achieve the greatest impact and reach with your food content. I'm confident the experience will be transformative for you and 100 per cent certain that, if applied with consistency, the insights and information contained within the book will help your wildest food-fame dreams come true!

How to Make Your Food Famous

Tell compelling stories

For people to notice your food content, it needs to be genuine and authentic.

There is a power in visual storytelling: photos and short-form videos are ultimately visual diaries into the world of the artist and creator. You can be open and vulnerable with your communication or you can be subtle by conveying your message through symbolism, leaving your audience to make their own interpretations. For instance, a cake alone on a table set in a vast void of dark negative space could illicit feelings of isolation and the use of crushing walnuts could suggest power and freedom. From lighting to props, there are so many things you can play with to convey your story through a recipe reel or food photo.

Finally, choose your music wisely. Music is the ultimate expression of emotion. If your short-form video doesn't include a voiceover, the music you choose then takes on the role of narrator. The music and visuals must be fully aligned with the mood and vibe of your story.

Telling compelling stories is all about sharing from your heart. It reassures the viewer they're not alone and that connection is key.

HOW IT ALL BEGAN…

… In late 2016 I signed up to train to become a pastry chef. However, a week before my course was due to begin, the school abruptly shut down. I decided to continue baking and cooking, as well as learning a new skill – photography. Eventually, I started a blog called 'Stems & Forks'. It was a culmination of all the things I love: photography, cooking and flowers. As my photography and storytelling skills grew, so did my social media audience. Each well-crafted and curated image helped my profile grow.

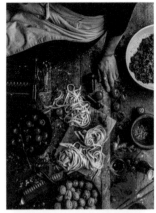
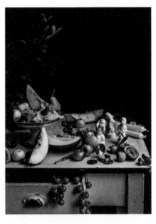
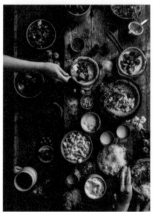
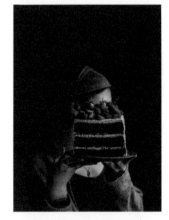

TIKTOK
@eatwithafia
521.3K

INSTAGRAM
@eatwithafia
309K

YOUTUBE
@eatwithafia
27.4K

Celebrate your roots

I saw the cultural shift that happened following lockdown in 2020 as an opportunity to finally share the recipes and talk about the foods I myself was eager to delve deeper into: West African vegan dishes. I'd already posted a few Ghanaian recipes here and there and they'd always had a great response, but it wasn't until that year that I went all in.

Celebrating my roots and sharing recipes steeped in West African traditions really put me on the map. Embracing the foods of my ancestors and sharing them with a Western audience allowed me to occupy a niche that was wide open and ready for the taking. It changed everything! Since then, my content has gone viral multiple times over the years, and consequently my community has continued to grow exponentially.

I also provide educational content around common West African ingredients and cooking traditions that are interesting to vegans and non-vegans alike. I'd shared some of these during my earlier blogging years as infographics on my Instagram, which people liked, but with the introduction of video I was finally able to make this content more accessible and relatable.

Having committed to learning more about my own heritage and doing the necessary research to bring the best content I can to my audience, I've continued to go from strength to strength.

As pretty pictures no longer dominate social media and video has instead taken over, I have had the opportunity to give my food content a distinct voice. Could the same apply to you? I feel that there's no better time to celebrate your roots through your food content and grow a following all of your own.

HOW IT ALL BEGAN…

… I started sharing recipes online in 2015, just after going vegan, as The Canadian African, though I didn't actually share many African recipes and instead dabbled with lots of different concepts as I was still trying to figure out what I wanted my page to be about. After growing painfully slowly for five years and feeling disheartened by the process, I decided to take my content creation more seriously and changed the focus of my page to sharing West African vegan dishes. From there, things snowballed year on year on year.

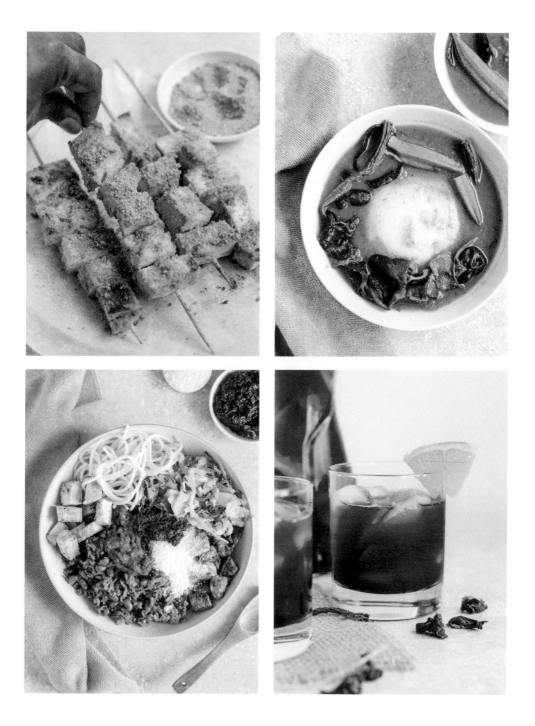

WHAT GEAR DO YOU REALLY NEED TO SUCCEED AS A FOOD CONTENT CREATOR?

Do you feel like you need the latest and greatest camera to create standout food content on social media? If this thought is what's holding you back from sharing your beautiful bakes and scrumptious salads with the world, then listen up!

As a food photographer with over a decade of experience, I often turn to my camera phone and some other easily accessible gear to get the food photos and videos I need to wow my audience and satisfy my clients; I know for a fact you can create droolworthy content with tools you have at home too. That said, I also share some ways to upgrade your gear if you're ready to take the next step forward on your food content creation journey.

So, with that in mind, here are my must-have gear recommendations.

A mic

If you love a good voiceover and adore some foodilicious ASMR, be sure to get a mini mic. Most microphones that plug into your phone or camera are light, portable and super affordable too! So, if audio is as important to you as the visuals and taste of your food, then a mic is a must-have!

By the way, you can find a list of the exact gear I use here on my website: thelittleplantation.co.uk/food-famous.

A camera / phone camera

If you're just getting started and looking to create deliciously gorgeous reels and TikToks, then your phone camera will do the job and do it well!

Honestly, the power of your phone camera is amazing; that's because the latest phone cameras allow you to make similar adjustments to those you would normally make on a professional camera. For example, you can adjust how bright or dark your video or image will look – we refer to this as EXPOSURE. You can make your background look dreamily blurry by changing the APERTURE on your camera phone and you can even film your videos in slow motion if that floats your boat. These were all functions previously reserved for DSLR cameras only, but are now widely available on most camera phones to make your leap into food content creation full of creative possibilities!

That said, if you're looking to start a YouTube channel or photograph food for cookbooks and magazines, then getting a DSLR or mirrorless camera will be essential. That's because of the higher image resolution that bigger cameras provide. This is key if you want to post high quality content on a YouTube channel or in print media; it's less relevant on TikTok or Instagram where phone cameras will more than suffice.

If in doubt, simply start with the camera you have, because it means you can hone your food content creation skills, share your love of food and build your online community sooner rather than later! Then, once you've found your stride, simply upgrade.

A phone/camera tripod

Have you ever tried holding your camera phone whilst chopping veggies or frosting a layer cake? It's impossible! That's where tripods come in handy; they allow you to do what you do best in the kitchen whilst ensuring your camera captures the food from all the right angles.

Most phone tripods are super affordable, but if you're not ready to take the leap yet, you can also lean your phone against a coffee cup to hold it in situ for straight-on captures. Alternatively, placing your phone on a shelf above the area you're prepping or cooking will enable you to film or photograph from that all important bird's-eye perspective.

For those of you using or ready to upgrade to a DSLR or mirrorless camera, a decent camera tripod is vital to avoid seriously shaky footage!

'If in doubt, simply start with the camera you have...'

TIKTOK
@thenarddogcooks
149.7K

INSTAGRAM
@thenarddogcooks
467K

YOUTUBE
@thenarddogcooks
441K

Find your style

In mere months, I grew my Instagram and TikTok to 100K+ followers. I didn't use any hacks, I didn't spend hours commenting on posts or doing all the things people tell you to do. Instead, I simply created the best food videos I could, and in doing so developed a signature style that resonated with people.

To grow on social media, it's important not to do things in exactly the same way others are. Avoid comparing yourself and your work with someone else; comparison moves you away from expressing your uniqueness and how you see things, it leads you to conform and feel as though you need to change, and it stops you from finding your own creative expression. Sure, you can use this book for inspiration, but then take that knowledge and find your own voice, rather than mimicking others.

My videography style focuses on storytelling. I try to make sure that every aspect of my video has characters, movement of the camera in some way, and emotive music that draws people in. I'll be honest, my video-making process is complex and often keeps me up at night – even a 30-second clip can take me days to produce. Sometimes, if I don't feel fully connected to what I've created, I explore ways to film my food

content differently. Fine-tuning my style is a never-ending process and it's far from perfect.

I'm always mindful not to waste people's time and to make the viewing experience fulfilling; like they're walking out of the theatre after watching a great movie. That's me, that's my style, now go and find yours.

HOW IT ALL BEGAN...

... My wife and I started a YouTube channel in 2018, but in the summer of 2023 I decided to start my own social media channel too, to build an audience and help people make better food choices. When I was growing up, I didn't have the power to do so, and hence am now committed to educating people about food and making a positive difference.

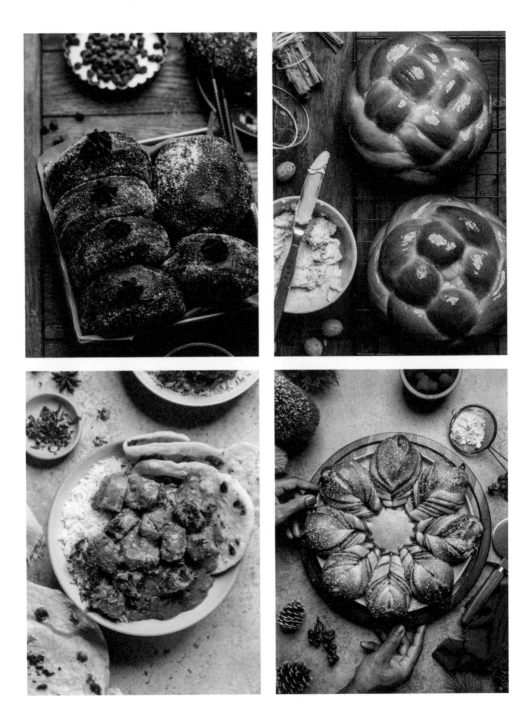

TIKTOK
@spicymoustache
2.6M

INSTAGRAM
@_spicymoustache_
4.2M

YOUTUBE
@SpicyMoustache
1.6M

Learn from your mistakes

Our growth on social media was steady at the start, with some big spikes after a few viral moments. But we also experienced periods in which our follower count dropped, our reach plummeted and our videos tanked. Even today, some of our posts underperform, but it doesn't unnerve us or stop us from sharing content about how to grow and cook your own organic food. Instead, we see mistakes as a learning opportunity; if a video doesn't resonate, we ask ourselves why, and try to identify exactly where we went wrong.

I recommend using all your spare time to figure out how to make your food content engaging. When we started out, we did so by reading books, watching endless YouTube videos, and taking photography and videography seriously. In the process, we developed a bit of a passion for it, studying every single part of the content creation process at night and on the commute to work, then applying that learning to iron out our mistakes. Once our food videos improved, we built on what we'd learned and did more of what worked. That's how we've been able to produce numerous pieces that have gone viral across TikTok, YouTube and Instagram!

Be sure to create food content because it's your passion, because it's what you love. That's

so important because the road to success isn't linear. Quite a few creators get started because they want lots of followers, tons of likes, and quick monetary rewards. They attach their self-worth to numbers, but doing so is your one-way ticket to burnout. If an intense passion for food and inspiring people isn't there, it means that when you don't constantly receive external validation, you're much more likely to feel low and give up. Instead, look at failures, mistakes and setbacks as part of the process, let them empower you, so you can continue to empower others.

HOW IT ALL BEGAN...

... It all happened super randomly. My fiancé and I love growing our own food and started sharing content about our gardening adventures in 2019. We posted sporadically until the first lockdown in 2020, when we started creating content more consistently, mainly in video format. We instantly got a great response. Since then, quite a few of our videos have gone viral, and we grew from 20K followers to 100K followers to over 8 million followers across TikTok, Instagram and YouTube, and now create content full-time.

'...we see mistakes as a learning opportunity; if a video doesn't resonate, we ask why, and try to identify exactly where we went wrong.'

FIVE STYLING TIPS TO ELEVATE YOUR FOOD

Is it just me or do the food images of some of the best-known fast-food chains make you want to head to the drive-thru as fast as possible? The food looks so droolworthy because someone, usually a food stylist, makes it look extra scrumptious for the camera. And whilst you don't have to be a professional stylist to get your food content noticed on social media, there are a few easy food-styling tricks that will instantly elevate your images and short-form videos. Here are my top five food-styling tips you can implement straight away!

Use garnishes

From herbs to chilli flakes, edible flowers to nuts or seeds, each meal and most certainly every cocktail deserves a final flourish! That extra drizzle of olive oil or grinding of coarse black pepper will not only take your food photos to the next level, but also add a touch of deliciousness to your food videos.

Colour me blind

Part of the reason that adding garnishes to your dish makes it look extra scrumptious is because you're bringing some colour into the mix. Be it a deep, rich brown from pouring a luscious chocolate sauce over a vanilla ice cream sundae, or a sexy red from sprinkling over pomegranate seeds to elevate a salad, colour always makes your food sparkle.

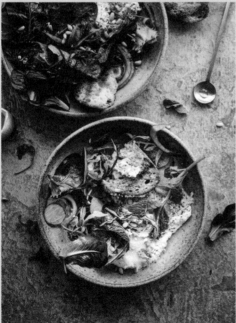

Keep it fresh

A wilted salad is one of my least favourite things to eat, and cold stew takes a close second place! That's because we all love something that tastes and looks freshly made. Hence, be sure to capture your food when it's just been taken out of the oven, pot, pan, blender or air fryer. Capturing food at its freshest will make all the difference to the beauty and impact of your food content.

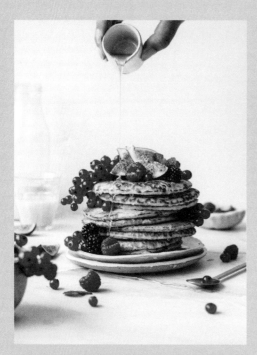

Make it saucy

Picture this: a bowl of pasta that is so dry it sticks together, versus a bowl of pasta with a luscious, rich tomato sauce . . . which one would you rather eat? When you style your food, add a dollop of this or a drizzle of that to ensure your food looks anything but dry, because it might be the key that stops everyone mid-scroll.

Be that little extra with pretty tableware

Be thoughtful about the tableware you use for your food content. A stunning plate, a gorgeous knife or beautiful bowl can transform how your food and drinks look. I've even noticed quite a few food content creators use gorgeous pots and blenders too, to make their videos that little bit more enticing.

'add a dollop of this
or a drizzle of that ...
because it might be the
key that stops
everyone mid-scroll.'

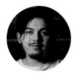

TIKTOK
@jose.elcook
1.3M

INSTAGRAM
@jose.elcook
1.5M

YOUTUBE
@jose.elcook
869K

Persistence pays off

When you work tirelessly on your food content and don't instantly see the results you were hoping for, it's hard not to give up. The truth is, I almost reached my breaking point around six months into my journey; I kept questioning why I was doing all this hard work. I was so close to giving up because for the longest time it felt like I was rolling a big ball up a hill, and it was tempting to let my posting schedule slip or to become complacent.

Instead I pushed through and, eventually, something clicked. You see, the more time that passed, the better I got to know my audience and what they really needed from me. The more content I created, the easier it became to produce short-form videos filled with value. The more I planned my recipes, the more skilled I became at sharing content people were actually looking for. And the more I realized that it wasn't about me but my community, the more my content went viral.

Just a few weeks after I was about to throw in the towel, my social media channels exploded and my content kept going viral. Consequently, in the space of 12 months, I increased my audience almost ten-fold – it was unreal! If I hadn't persisted, I wouldn't be where I am today.

Success always lies on the other side of persistence, and I'd encourage anyone who wants to grow an audience online and have real impact to persevere, because it really does pay off.

HOW IT ALL BEGAN...

... After years of thinking and talking about it, I finally started my social media accounts in May 2022, in order to share my passion for all things cooking with the world and find an outlet for all the recipes I had amassed over the years. I loved sharing recipe videos, and was instantly hooked on the creative process of filming and sharing recipes and kitchen tips. It felt like an escape from the humdrum of day-to-day work. Despite a very slow start, I was able to grow my TikTok audience to 1 million followers and I am now a full-time content creator.

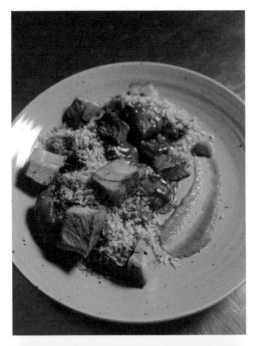

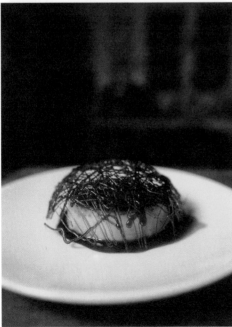

'the more I realized that it wasn't about me but my community, the more my content went viral.'

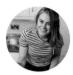

Own your niche

In the beginning I shared everything and anything I was eating, but as time went on, I noticed that I got the most enjoyment from sharing vegan desserts. Though it's a niche within a niche, the content I focus on is an area many people find tricky because desserts often contain dairy and eggs. Once I narrowed down so specifically, my content started to perform pretty well.

Instagram is becoming more and more saturated, and there are so many people doing similar things, that it's more important than ever to give people a clear indication from the outset of the type of content you share and what they can come to expect from you.

To distinguish themselves from other accounts, many food creators are now stepping in front of the camera, but as a super introverted person, I try to avoid doing so. It's for this reason that establishing myself as an authority through narrowing down my food content has become even more important.

Showing people that you have expertise in a particular area, that they can trust your recipes and your recommendations, is how you become known and respected. It's also how the algorithm starts putting your content in front of the people who are looking for what you have to offer.

Creating your own niche isn't just important on social media, it's also really helpful if you're thinking about starting a website or blog, as Google will rank you more favourably. But be mindful of the fact that you will limit the brands you can collaborate with, especially if your niche is very small or specific.

Consider your goals carefully and take it from there.

HOW IT ALL BEGAN...

... I started my Instagram account in 2016. I had just gone vegan and was looking to not only share everything I was learning about plant-based cooking, but also to connect with an online community. Simultaneously, I was having an existential crisis – unhappy in my job, I desperately needed something outside of work that felt fulfilling and allowed me to be creative. After a year, I thought Addicted to Dates could become something more than just a creative outlet, and from 2020 onwards I treated all my channels as a proper business. I now create food content full-time for brands.

LIGHTING YOUR FOOD TO PERFECTION

The secret to the perfect food photo and engaging food video is not a sprinkle of salt, but exceptional lighting! Though a sprinkle of salt most certainly will help too, correct lighting is what can truly turn a plain bowl of oatmeal into a show-stoppingly gorgeous breakfast that even the carbophobes can't say no to.

Now, before you go out to purchase that ringlight you've seen everywhere, let me reassure you that more often than not, the sunlight coming through your window will do just as well and is the quickest, easiest and best option to get you started right away!

If you're eager to create food content using natural light, here's what's important to consider.

How close are you to your window?

Ideally, you want your set-up to be situated right next to your light source for the best outcome. This may mean shifting things around or – like me – capturing food content in a space that isn't your kitchen! For those of you eager to share food content from restaurants or cafés, be sure to grab a seat right next to the window for the best possible captures.

Create content during the day

Cloudy days are fine, but if the sun's gone down just as you've finished cooking your dinner, natural light will no longer be able to let your food truly shine.

Bigger is better!

If you're working with natural light, it's really helpful to work beside a large window. Tiny windows that allow very little light into your space won't adequately illuminate your set-up and hence not allow your food to look as tantalising as it tastes.

If you simply can't make the natural lighting in your home work for you, then artificial light might be your best bet. Here are some things to consider.

Get a rectangular clip-on LED light

Though ringlights are great for selfies, the rectangular clip-on light is fab if you want to capture evening meals at atmospheric restaurants or spectacular cocktails inside moody bars.

An all-in-one softbox continuous light

This lighting set-up can help you photograph and film your delicious dishes with ease. One might be all you need, but some food content creators like using two for extra brightness.

Professional continuous lighting and softbox

If you're eager to go to the next level, then a professional light is the way to go. It tends to illuminate better than the all-in-one softbox because it's considerably more powerful. However, a professional light used in combination with a good softbox will allow not just your food but also you to look picture perfect.

Whatever lighting option you go for, be sure to remain close to your light source and turn off any lighting that might interfere with your final result. You got this!

Harsh artificial light

Natural diffused light

TIKTOK
@daenskitchen
2.7M

INSTAGRAM
@daenskitchen
770K

YOUTUBE
@daenskitchen
1.35M

That sounds delicious!

When I started my Instagram account, there was only the option of posting pictures, but in 2020, when short-form video in the form of Reels became a thing, a whole new world of creative possibility opened itself up to me.

That said, when the ASMR video format emerged, I was initially reluctant to embrace it – my partner works from home and I had a newborn baby, so it felt impossible. Then I started filming really short recipes when my baby was sleeping or out with my mother for a walk. I often had less than an hour to create these videos, but used my limited time to capture them, focusing fully on ASMR (autonomous sensory meridian response – the response triggered by delicious audios and visuals). Those first ASMR toast videos went viral and changed everything for me! In particular, it was the sound of olive oil being drizzled onto the toast, as well as the toast sizzling in the pan, that strongly resonated with my audience, and people often comment on how soothing they find my videos.

Other sounds that people have found relaxing include the glugging of olive oil, and garlic falling into a ceramic dish. These two ASMR sounds always seem to stir emotions, leading to more likes, more reach and more follows.

It's taken time and practice to learn how to cook food so that it will create the sounds that people respond to, but it's fun to experiment and the results are worth it. I've also found that recording my videos in an echoey room creates the crispest sound. Using an external (small and portable) microphone is essential, as well as ensuring your recording space is quiet.

ASMR has been a total game-changer for me and is fundamental to my audience growth. Do give it a try!

HOW IT ALL BEGAN...

... I felt a little lost in my marketing career; the passion for my work had gone and, as I had some time on my hands following a change of jobs, I decided to start a private food-based Instagram account in 2019 to share my recipes with family. I'd always loved food and quietly dreamed of starting a cooking blog – then suddenly, the time felt right to give it a go. I made my Instagram account public, and shortly after that opened a TikTok account too, and, following a slow and steady start, things just skyrocketed from there. Creating content is now my full-time job and I absolutely love it!

TIKTOK
@katies_little_
15K

INSTAGRAM
@katies_little_bakery
140K

Share your behind-the-scenes

After a patchy start to my Instagram journey and some time away from social media, I committed to sharing my content consistently, not as still images, but in the form of reels, specifically behind-the-scenes reels, giving my audience a glimpse into my life as a baker.

Unlike the very short reels that were all the rage at the time, I focused on videos that gave viewers the chance to see how my bakes were created, how I stacked layer cakes, how I decorated them, how I approached every aspect of the baking process; importantly, I didn't share these as 'how-to' or educational videos, but more as a way of bringing people into my world.

Then, after around 12 months, something shifted, my growth became more exponential and I suddenly gained 15K followers in just 10 days, simply from sharing lots of behind-the-scenes videos. Then there was another shift after one of my reels went viral. In this one, I shared the emotional ups and downs connected to being a cake baker, the true behind-the-scenes, if you like – the hard work and the self-doubt behind every cake that's baked with love. It was a spur of the moment decision to share a reel that was so raw, but it captured what was in my heart at that moment and led to a growth beyond anything I had experienced before, I think because it made me more relatable.

Though I haven't shared another R+eel as raw as the one that went viral, I still do share a 360-degree perspective of my life as a baker – from glimpses into my kitchen, to bakes I'm proud of, and lots of failed attempts too.

HOW IT ALL BEGAN...

... I started sharing cake recipes on Instagram in 2020, and primarily posted in Russian, which is my first language. I grew to 12K followers over the course of two years, but after a creative shift, I closed my original account and focused solely on my second Instagram account from early 2022 onwards. For this account, I solely created content in English. I feel that first cake account taught me how to create content, and after a very slow start, my current Instagram account grew to 100K+ in just 18 months, thanks to consistently sharing behind-the-scenes footage.

TRENDS — SET, FOLLOW OR AVOID?

It's impossible to open TikTok or scroll through Instagram without hearing the latest trending song on repeat or seeing that 'must-try' recipe on all your favourite foodie accounts. Trends are easy to spot, but do you need to follow them to become food famous?

As you'll see from the tips shared by the food content creators in this book, there are many roads to success, and when it comes to your approach to trends, that same principle applies. So on that note, let's take a closer look at the options open to you.

SETTING TRENDS

If you're super creative in your recipe development, like Lina was with her insanely delicious viral creation, the date bark (@thathealthjunkie, page 72), or if you have an uncanny eye for spotting undiscovered and unmissable restaurants, then do live your best trendsetting life! The social media world desperately needs more trend-setters, and know that your trailblazing ways will certainly allow you to stand out from the crowd. Be sure to read Lina's suggestions for tips.

FOLLOWING TRENDS

To make a name for yourself in the online food space, it's paramount to have your finger on the pulse and to understand cultural shifts within the food scene.

Jumping on a food trend at just the right time can undoubtedly expedite your audience growth; it can also simultaneously reassure your current online community that you're in the know when it comes to what's hot and what's not, and can even signal to food brands that you're a true foodie who can be trusted to create the right food content at precisely the right time. But beware, jumping on a food trend a pinch too late, when it's overdone and lost its sparkle, can backfire, so if you're going to embrace trends, get the timing right!

AVOIDING TRENDS

If trends don't speak to you at all, if they don't ignite a fire in your belly, if they don't represent how you want to express yourself as a food content creator, photographer or chef, then avoiding them might be the best way forward. You see, if there's one thing that is 'trendy' yet timeless, it's being authentically you.

Rest assured that avoiding trends and embracing classic, undeniable deliciousness instead can be equally as valuable (and hugely popular). In fact, it can be just the thing that allows your food to become famous.

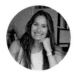

TIKTOK
@myriadrecipes
315.4K

INSTAGRAM
@myriadrecipes
290K

Create a series

When I decided to start my social media accounts, creating a series gave me something specific to aim for and research. I love dumplings, so 80 dumpling recipes from around the world seemed like the perfect first series to share.

There are hundreds of dumpling recipes from around the world, so the real challenge was picking 80 that I could celebrate and put my twist on. Initially, no one noticed me or the series, but when I hit dumpling recipe number 40, I realized I had an audience of 15K followers on Instagram, and by the time the series concluded, I had amassed over 100K followers, with things skyrocketing at dumpling number 73! It's fair to say that creating a series has been instrumental to my growth on social media.

Completing a series felt like a real achievement and I noticed that my audience were truly invested in my journey; they awaited each recipe with anticipation. Even people that weren't part of my community were aware of what I was doing, so there was almost a brand recognition around my name and the series I was creating. Plus, as a food content creator, it's normal to have moments where you encounter a creative block, but a recipe series gives you a clear path and structure to follow to break through those barriers.

I've done many more series since I shared my dumpling recipes, and found that if you persevere and are committed and passionate about the topic you're sharing, it'+s most likely to resonate with others too. That said, if you get bored with a series, or it isn't bringing you joy anymore, it's ok to change course.

Though getting followers from sharing a series was a great side-effect, it wasn't my main goal, and I wonder if doing it for the love of food, rather than solely the desire to grow an audience, is the ultimate recipe to success.

HOW IT ALL BEGAN...

... I was working in marketing in May 2021, but really wanted to get into recipe development. As much as I tried, I struggled to get hired because I didn't have any culinary qualifications and there was no evidence of what I was capable of in the kitchen. So I set up Instagram and TikTok accounts to provide future employers with evidence of my love for cooking. The 80-dumpling series kick-started my online presence, helped me grow an audience and allowed me to become a full-time content creator within a year!

TIKTOK
@georges_bakery
415.5K

INSTAGRAM
@georges_bakery
126K

Ace the voiceover

In the beginning, the content format for George's Bakery was exclusively focused on photography. Though photos allowed me to show off my delicious bakes, it was hard to stand out from the crowd and, as someone who didn't study photography or own a swanky camera, even harder to grow an online community from posting still-life images alone.

Then TikTok came along and changed the game! Video content took centre stage, and given that TikTok started as a music-based app, audio became central to the creation process. That's where I saw my opportunity to inject some personality into the baking content I was sharing.

When it came to audio, I focused less on finding the best trending song and more on acing my voiceovers; though they are always different – sometimes fast-paced and loud, other times quite dry and gentle – my sense of humour and personality feature big-time in all of them.

I'm thoughtful and strategic when I create my voiceovers and aim to catch people's attention immediately to ensure I stop them in their scroll. My favourite way to start a voiceover is by saying 'Oh my God', which instantly evokes a sense of curiosity. I also look at what's going on in the media, jot down any funny phrases whenever they come to me, and ensure I build these in when I record my voiceovers.

I feel confident working without a script and am not afraid to record something off the cuff and in the moment. The only thing I am always mindful of is editing my visuals first, noting down the length of my final edited video and then timing my voiceover so that it fits the piece perfectly.

Getting your voiceover right does take practice, but it's an incredible way to inject some personality and fun into your content, especially if you're a little bit camera shy.

HOW IT ALL BEGAN...

... I started an Instagram account for George's Bakery in 2015, but found it hard to grow an audience whilst also building my baking business. Then, in 2021, when TikTok became the place to be, I started an account, and for the next 18 months, focused on growing my community there, amassing over 400K followers in less than two years. I know for a fact that my voiceovers played a huge role in that growth because they allowed me to create food content that was unique, noteworthy and full of personality.

FILMING ON YOUR PHONE – SIX SETTINGS YOU NEED TO GET RIGHT

Perhaps you're old enough to remember the days when all you used your phone for was to chat with your besties. Now it's a mini computer that connects you to the internet, helps you take spectacular food photos, and even gives you the creative freedom to film your cooking content.

Though the evolution of the smart phone has undoubtedly made sharing inspiring food photos and videos easy and accessible to all, it's also fair to say that with so many functions and settings to choose from, creating content on your phone can at times feel rather overwhelming. That's why I'm here to break everything down for you, from image resolution to frame speed, so you can always capture the best food videos.

Video resolution

Video resolution is all about how many pixels are contained within each frame; the higher the resolution (the more pixels you have), the crisper and sharper your videos will look. A lower resolution can make your videos look blurry, dull or pixelated.

Most mobile phone cameras allow you to film at 720HD, 1080HD or 4K, with the latter the preferred option for the most serious phone videographers. Though 4K will yield the crispest content, it takes up a lot of storage space. Consequently, you either need to save your videos to a cloud or external drive, or delete the content once it's been used. Limited storage space is one of the reasons food content creators sometimes film at 1080HD – video content at this resolution is not to be sniffed at, and is sharp enough if you're sharing content on platforms like TikTok and Instagram. Why not give both settings a go and see which one you prefer.

Focus on the food

It's heartbreaking to create a stellar recipe video of that once-in-a-lifetime dinner at the Michelin-starred restaurant, only to look at your footage afterwards and find that nothing was in focus. Trust me, I've been there and it's not an experience I'd wish on anyone.

To ensure every morsel of the food you want to showcase is clearly visible, pick your focus point before tucking in to your food. Nailing your focus point is especially important if you're hand modelling for your reels or TikToks as well as filming all by yourself at the same time, as you can't adjust your focus point whilst in the middle of filming. All that's required to ensure your footage is sharp is to set your focus point before filming on your camera or smart phone, and voilà! All sorted.

incorrect focus

incorrect focus

correct focus

Frames per second

As well as choosing your video resolution, most smart phones also give you the option to choose how many frames per second (fps) at which you wish to capture your video footage. That's because the video content we see actually consists of lots of images (frames) strung together to create motion footage.

The most common fps options are 30, 60 and, in some cases, 120 or higher, with each number representing the amount of frames used to create just one second of video content. Therefore, the more fps, the smoother the footage. That said, 30fps still allows you to create food videos that look professional and crisp; it also takes up the least amount of storage space and makes your videos look light and bright. It's my preferred fps setting.

However, 30fps isn't ideal if you wish to feature slow motion in your food video because the footage will be jumpy and awkward. You could instead film in slow motion mode, though I would avoid this and instead simply capture your footage in 60fps, then slow the footage down during the editing process; it'll be seamless and will allow you the greatest amount of flexibility. It's for this reason that some creatives film all their content in 60fps, as it gives them more options when putting together their final short-form video.

A word of caution, however: you will need to use a tripod (see page 18) for slow-motion footage, to avoid your food videos looking shaky.

Tinker with your lighting

Your food photos and recipe videos will look extra scrumptious if they are lit to perfection. Though the first port of call is always to ensure you have enough light to work with, you can adjust the brightness or moodiness of an image from inside your smart phone too. It's never a great idea to be too heavy handed when changing the brightness of your footage as this can impact your image and video quality, though a small adjustment can work wonders.

'Your food photos and recipe videos will look extra scrumptious if they are lit to perfection.'

Use the right lens for the job

Most smart phones now come with multiple back lenses built in – this often includes a standard wide lens that captures your food in a 1:1 ratio, as well as a wide lens (0.5:1 ratio), and sometimes even a zoom lens with 2x or even 3x capacity. To keep your captures as crisp as possible, use the right lens for the job and get as close to or far away from your subject as you need to rather than zooming in or out.

Grid view for the win

Every camera phone now has a grid view to help you capture the most visually pleasing food content. Grid lines ensure your footage is straight, avoiding excessive cropping later, and help you see clearly what will be in the centre of your capture; this is of the utmost importance for reels, where the top and bottom of your videos are cut off, unless users click to view your reel in the full 9:16 ratio. It's also important to see exactly what's in the centre of your frame for platforms like TikTok, where text and a multitude of buttons can cover content that's on the periphery of your food video.

TIKTOK
@turnipvegan
381.5K

INSTAGRAM
@turnipvegan
714K

YOUTUBE
@turnipvegan
165K

Videography skills come first

After filming vegan restaurants and cafés for a few years as a hobby, I decided to film my own content when we went into lockdown in 2020. The first video I created of my food – a supermarket pizza I jazzed up a little – did really well, which shocked me. It dawned on me then that the videography skills I'd taught myself over the past few years were essential tools in the changing social media landscape.

Even though I knew my way around a camera, my videos were long, protracted and lacked structure, which meant that they couldn't have the impact I wanted. Then I got invited into a programme, where they taught and then challenged us to produce compelling videos in 15 seconds or less. Through the course I learned how to tell an interesting story in a short period of time. It changed everything for me. I kept building on everything that I'd learned and then took those videography skills to Instagram and YouTube, where I experienced exponential growth as a result of my high-quality videos.

Excellent videography skills means you are able to communicate your food story in a much more enticing way – knowing how to tell a story, how to edit your footage so the food looks beautiful, how to create a vibe, and how to choose the right music to pull everything together.

I've tried using my phone to capture my reels and TikToks, but I've never been 100 per cent happy with the results; I feel it doesn't fully capture the story I want to tell, doesn't enable me to create my own unique style or allow people to truly feel the food. It's why I use a DSLR camera instead and would recommend anyone who wants to produce stand out work to do the same. It really makes a difference because visuals are so important.

HOW IT ALL BEGAN...

... I have always had an online presence because I used social media channels to promote my music, but I started posting my food content online in November 2016 when I went vegan. It was a way to share what I was eating and to dispel misconceptions about veganism. It never really took off until the pandemic happened in 2020 and I started to take my videography skills to the next level. That led to a 20-fold increase in my Instagram audience, and a community of over 350K on TikTok!

TIKTOK
@camillechamignon
126.6K

INSTAGRAM
@camillechamignon
288K

Plating to perfection

I put a lot of thought into how I style my food; I want everything to be gorgeous. In order to have things look the best they can, I shoot my recipe videos at my parents' house in the countryside. They have a big garden where I source beautiful produce, not just to cook the food in my videos, but also to decorate the final scene. For example, if I make a recipe with citrus fruit, I always set aside a few whole fruit with leaves and stems intact that will feature in my content. It adds another dimension to my styling.

I approach my recipe reels in the same way that I approach styling a food photo. The reels that have performed best and gone viral have been the ones that are the most visually enticing. For example, I made a pumpkin focaccia, in which I created little pumpkins to style the top of the dough, and added slices of pumpkin to finish the dish.

Another recipe that really struck a chord was my leek gratin; I think it was the fact that I styled the leeks vertically, which added a little originality to the recipe as well as visual appeal. Attention to detail in food styling is everything.

I really like rustic, minimalist food style, where the food and how it's plated is front and centre. Apart from the final dish, I only showcase the products used in my recipes in my content, without too many embellishments or distractions. I use platters and dishes that are vintage, but not clichéd, then I simply focus on plating everything to perfection to really draw the viewer in. It's worked a treat!

HOW IT ALL BEGAN...

... I started my Instagram account around 2018, but only started posting content more seriously and consistently in 2020. My intention was to use Instagram as a portfolio because it seemed obvious that doing so was essential to getting noticed by brands and prospective clients. Even though I didn't really have many followers when I started, I had a goal of reaching 10K followers within a set timeframe. By sharing food in the way that I do, and by utilizing the short-form video format, things took off and I surpassed that goal super quickly.

HOW TO TELL YOUR FOOD STORY

From fiction writers to film directors and now food content creators – we all need to know how to tell an enticing story. That's because excellent storytelling is the ultimate medium through which we can obtain the number one currency in this social media era: attention!

Now, I know what you're thinking: I only want to share my favourite foodie hot spot or the best pasta dish on the planet, not create a blockbuster movie. And I hear you. But the thing is, for food videos to stand out on social media, you need to master storytelling. More specifically, becoming a great storyteller involves knowing how to create a well-structured story arc, even if all you're doing is sharing your latest cupcake recipe.

Though the algorithms will forever remain a mystery, one thing is for sure: if you tell a compelling, mesmerizing food story, you will 'beat' the algorithms. Here are the three components that comprise a good story arc.

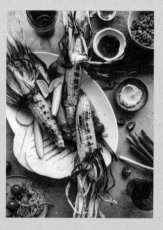
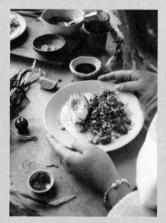

HOOK

By far the most important storytelling element to master is creating a strong hook at the beginning of your food video; something that will stop people in their scroll. Creators like Shanika (@orchidsnsweettea, page 126) do this incredibly well, and without it, it's very hard to get noticed on what is becoming an increasingly crowded online food space.

If you're just getting started, here are some easier hooks to play with, though the options are endless:

+ Use a title or text overlay at the start of your food video to explain exactly what your content is going to be about.

+ Show the end result of your cooking extravaganza at the beginning of your reel or TikTok video, as Shanika does, to get people salivating from the get-go.

+ Add a show-stopping voiceover that intrigues people from the outset, just like George (@georges_bakery, page 44).

ACTION

It's one thing to grab someone's attention with your content; it's a whole other ballgame to keep them engaged. Yet it's precisely your ability to keep people watching – your retention rate – that will set you apart from everyone else and allow you to move up the algorithm ranks. That's because Instagram and TikTok put tremendous weight on retention rate, as it's in their interest to keep users on the platform for longer. So how can you keep people interested in your content when the next creator is just one scroll away?

You need to avoid the big B: boredom! You can do so by putting action at the centre of your content, be it through awesome transitions and good pacing, satisfying ASMR (see Daen @daenskitchen, page 36), trending voiceovers, or all of the above. Go all in on whatever builds anticipation, excitement, curiosity and keeps people interested in your food story.

CONCLUSION

You caught their attention, you held their attention, now you need to give your online community the conclusion they've been waiting for and deserve. Be it the taste test, the breaking of the bread so we can hear that delicious crunch, or an irresistible cheese pull as you lift the first pizza slice off the baking tray – whatever you do, make it scrumptious!

TIKTOK
@plantboiis
3.7K

INSTAGRAM
@plantboiis
43.1K

@bensvegankitchen
@calumharris
@eatsbywill

@jacobking
@johnnymeatless
@nomeatdisco

@sepps
@vegenezer
@vgangreviews

Collaborate

To make a collaboration between food content creators successful, you need to genuinely get on and be open to learning from one another. We're all really good friends, which translates well on camera and makes the entire process of food content creation a lot of fun. Before we start filming, we bounce recipe ideas around in our group chat and brainstorm ways we can make our collective content more engaging and entertaining.

Collaborating on our joint channel (Plantboiis) as well as our individual channels allows us to reach each other's audiences, which helps with growth, though that's not why we do it! For us, it's more about spending time with each other and being inspired, sharing our knowledge and learning from one another. So, if you're thinking about using collaboration as a growth strategy, be sure to look for people you genuinely like and whose content and values align with your own. You want to create food content with people who push you out of your comfort zone and encourage you to become better at what you do.

You don't need to be in the same physical space as your collaborators – you can collaborate and create across countries and continents. It takes a little more planning and a clear distribution of roles and responsibilities, as well as some good editing skills, but it's super fun and a great way to make the most of the collaboration feature on social media.

Finally, keep comparison out of the picture and instead focus on supporting each other. This allows for mutual respect, trust and friendship to grow, and makes way for the best possible recipe content for your respective audiences.

HOW IT ALL BEGAN...

... After Ben posted about his favourite male vegan content creators in 2020, we all connected on Instagram and just clicked. In late September 2020, Johnny opened a group chat on Instagram and Calum came up with the name Plantboiis. At the start there were seven of us – Ben, Calum, Johnny, Jacob, Will, CJ and Ebenezer – but we decided to invite Giuseppe and Sam to join us because we felt like they would complete our group. We each bring something unique to the table – from our different cultural backgrounds and cooking skills, to our food photography and videography knowledge – and it just made for the perfect synergy. It wasn't long after that decision that our content caught the eye of some big brands, and we haven't stopped since!

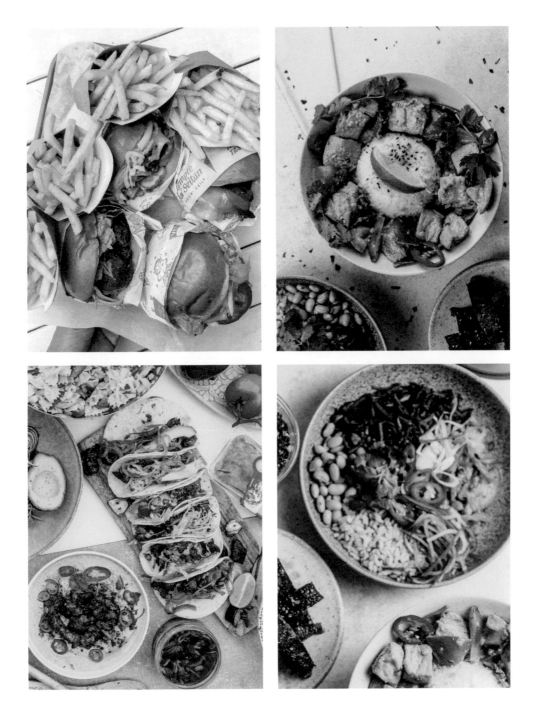

TIKTOK
@thekoreanvegan
3M

INSTAGRAM
@thekoreanvegan
768K

YOUTUBE
@thekoreanvegan
1.09M

Embrace your vulnerability

The most effective way to make a person feel safe is to be vulnerable first.

I didn't start sharing my personal stories to go 'viral'. I just wanted people to feel less alone and to do that, I needed to make myself vulnerable. I shared what some might view as private moments, thoughts that I kept close to my heart, hoping they might resonate with others. I did not expect the growth that followed.

What I have come to understand since is that going viral on social media is only the beginning and is the easier part. What's harder is turning all those millions of views into an online community. If you encourage people to open their hearts by baring your own, chances are, they're going to stick around. Those sorts of exchanges are the seeds to a powerful community.

Revealing yourself to strangers isn't always easy, but it disarms people in the same way it does when a person you don't know lends a helping hand or extends a kind word. But the online community has grown quite savvy. Therefore, it's imperative that storytellers share themselves with sincerity. Performative vulnerability – sharing something under the guise of candor with the aim of going 'viral,' hurts not just your chances of building a strong,

sustainable community, but risks damaging those who are genuinely seeking fellowship. When I share something personal, I like to make sure there is distance between myself and the events I'm talking about; sharing when things are raw and unresolved can be tricky and emotionally dangerous. I highly recommend that you set boundaries around what you're comfortable sharing and what is off limits.

HOW IT ALL BEGAN...

... After going vegan in 2016, I started an Instagram account, not only to share my food creations, but to hold myself accountable to this new mode of eating. In 2017, I started to weave more personal storytelling into my food content, following a divisive election year. In doing so, I hoped to provide a safe space for my community and prove that we have much more in common than we realize. It wasn't until 2020, when the mix of my Korean vegan recipes, my storytelling, and the new short-form video format came together that my content started going viral! Less than two years later, I left my 17-year career as an attorney to focus completely on The Korean Vegan.

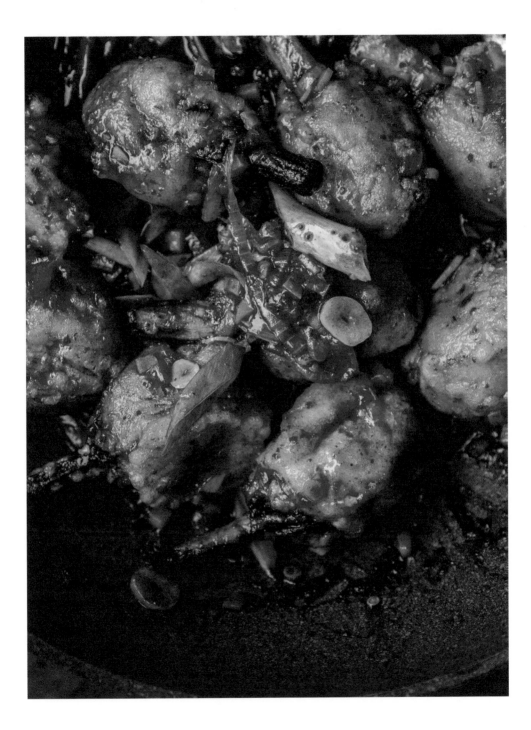

IT'S ALL IN THE EDIT

Is your food utterly delicious, your lighting on point and your consistency enviable, yet for some reason the views, likes and follows still aren't happening for you? It could all be down to how you edit your food content. Here are some ideas to help you nail your editing.

Editing your food photos

If you're sharing your food photos on Instagram or TikTok, it's great to apply a consistent style, so your audience knows from the outset that it's you. You can develop your own look simply by using presets or filters, ideally ones that have been specifically designed to be used for food photos, and then adapting them to your liking. Using the same presets on all your food photos will give them a unified look.

Alternatively, you can edit your images using a trial-and-error approach until you find a look you love. Here are some adjustments worth playing with when editing your food photos:

+ **Exposure.** Make the food as bright or as moody as you want it to be.
+ **Colours.** Changing the colours in your images is the best way to create a signature look. You can enhance the colours you love and correct those that didn't translate as well through the camera.
+ **Contrast.** Changing the contrast in your food images can really make them pop, making them appear more three-dimensional and eye-catching.

Getting these three settings right is a great starting point, but remember there are lots of other elements to play with when it comes to editing your food photos like a pro. The following awesome photo editing platforms have endless options to inspire your creativity:

+ Lightroom (my personal favourite)
+ Snapseed
+ VSCO
+ Afterlight
+ Instagram (now remarkably powerful as a photo editing platform too)

Editing your food videos

Editing your food videos is as much about getting the exposure, colours and contrast right as it is about the two Ts of editing: timing and transitions.

Timing

As you edit your food video, think about how long you want it to be, then edit your content accordingly. If you're at the start of your food video journey, it's especially important to keep your content short, sweet and to the point; it avoids you losing people's attention prematurely and slipping down the algorithm ranks. It also allows you to create and edit more content in less time. Only once you're more confident in your editing and have built trust with your audience would I recommend looking into food videos that extend beyond 30 seconds.

Creating content that isn't too long, yet conveys all it needs to, is a skill that takes practice. Here are some tips that may help you nail your timings:

+ Keep video footage of each separate step of your recipe to around 1–3 seconds; we don't need to see you peel and chop your vegetables in real time!
+ Set a tempo for your video that suits your unique style and music choice. If, like Rana (@ranasmag, page 120), you love working with upbeat music, then creating dynamic food videos that are fast-paced and energetic could be the way forward for you. At the time of writing, this style is indeed all the rage. Luckily we're all different, and gentle pacing, which might include slow-motion footage, as demonstrated so beautifully by Val (@appetite.life, page 138), can be just as attention grabbing, popular and effective.

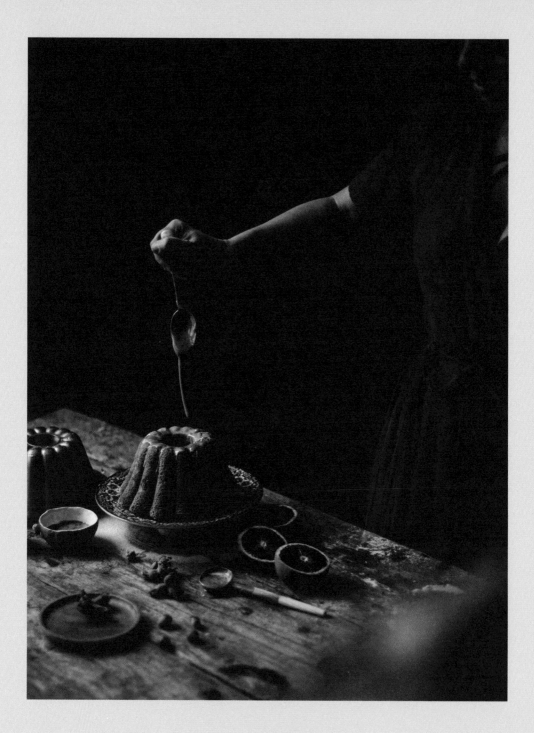

+ Focus on the juiciest elements of your food story only. The fact that you threw away the pit of the avocado whilst creating your avocado on toast recipe, or waited patiently to be served when visiting that special restaurant, are not essential to your story or of much interest to your audience.
+ Use a reels template on Instagram. This allows you to time your video footage perfectly to the music, which can really help to set the right pace.

Transitions

Strictly speaking, 'transitions' is a fancy way of describing how you move from one video clip (cutting onions) to another (pan frying said onions in olive oil) beyond simply stringing different video clips together. Transitions provide a bridge between different scenes of your food video, they keep the pacing of your content engaging, and can themselves be used to showcase your creativity, uniqueness and personality.

A very common transition includes creators snapping their fingers to turn simple ingredients into a complete meal in a fraction of a second, but there are many more styles to play with too.

The good news is that many video editing apps, like InShot, CapCut and VN, have transition options built into their features, to make engaging transitions a complete breeze. However, I'd never advocate overusing transitions, as this can feel forced and predictable, but a few inserted in precisely the right places can work wonders.

The soundtrack

When editing your food videos, the audio is (almost) as important as the visuals. In fact, music is baked into TikTok's DNA, as it started out as a video sharing app where young people lip-synced and danced to their favourite tunes. In terms of Instagram, all it did was adopt TikTok's winning formula and make music a key component of its short-form video feature, Reels.

As mentioned, music can help your pacing, but it can also give your food videos more personality, enable you to tap into a trend and, ultimately, allow you to tell a better food story. Hence, the choice of soundtrack is key!

In short, acing your edit will set you on course to creating content that will reach a wider audience and allow you to truly stand out.

TIKTOK
@cocinaconcoqui
3.7M

INSTAGRAM
@cocinaconcoqui
852K

YOUTUBE
@cocinaconcoqui
1.11M

Do something different

I think part of the reason my content went viral from the very beginning is that I filled a gap in the Spanish food-content space. Spanish content creators are incredibly proud of their cuisine and focus on really traditional recipes in their videos. And rightly so, as Spanish food is delicious, but I noticed that there wasn't anyone in Spain who was sharing recipes like mine.

People often have a sense that Chinese dishes and foods from other Asian countries are complicated to prepare, so I make a point of showing how easy, delicious and achievable they are. No one was doing this when I started and that instantly allowed me to stand out.

You don't have to be a cultural or ethnic minority in the country you live in to get noticed, but you do need to carefully consider how you can make the food content you share on TikTok or Instagram unique. As both platforms are so saturated now, it's important to post something that's interesting and eye-catching; this may mean editing your videos in a way that's fresh and new, creating a recipe that has a special twist, or filming your content in your own signature style that's unlike anyone else's. The possibilities are endless.

The three ways to ensure that what you do is indeed different are: firstly, by studying what's already out there so you can discover what's missing. Secondly, by pulling together a multitude of content creation ideas that inspire you, and mixing them up in your own unique way. And finally, by creating food videos you truly love, that come from within you. This way, your content is bound to stand out and get noticed!

HOW IT ALL BEGAN...

... I started my TikTok and Instagram accounts in September 2021 when I left my job, moved to a different city and found myself with lots of spare time on my hands. As TikTok was still relatively new, it was easier to get noticed, and consequently my content went viral overnight, with the first recipe video I ever posted receiving over 1 million views. After posting a number of recipe videos that all did extremely well, I discarded the idea of searching for another job and decided to put all my efforts into full-time recipe content creation.

INSTAGRAM
@thefirstmess
302K

YOUTUBE
@LauraWrightTFM
2.58K

Community first

In order to build and maintain an online community, the key is to know your audience inside and out. Close your eyes and try to envisage who is consuming your video and photo content and who is reading your words. What kind of life do they lead when they step away from social media? What exactly do they need from you, and how can you serve them content that's going to make their life better?

It's important to be consistent in connecting with your audience in order to be able to continue to create content that meets their needs. I've found that using the question box on Instagram can be a great way to keep the doors of communication open. I provide my community with the opportunity to ask questions every week on the exact same day, so they know their chance to have their questions answered is coming. I also step in front of the camera weekly to share cooking tips I hope are of value; showing my face is another great way for me to connect to my online audience.

I want to create recipes people will love, so apart from asking what they'd like to see more of, I also check my stats – how many comments, questions, saves and likes did a recipe reel get, and what does that tell me about the type of

food content my community likes best? Finally, I use the poll feature on Instagram too, because it gives me further details that I can't obtain elsewhere, such as whether people are still enjoying using their Instant Pot, how they feel about their air fryer, and so on.

In short, put your community first! Then create content that meets them where they are at. It's allowed me to build and maintain an engaged following and it's key if you'd like to achieve the same.

HOW IT ALL BEGAN...

... When I started posting on Instagram in 2014, it was more for my own creative expression than as a promotional tool for my food blog. Things took off on social media for me from the very start, even though I had no strategy and was essentially posting just for fun. Around 2015–2016 my audience grew rapidly, as larger accounts would repost my content and as a result I'd gain well over 5K followers in just one week. More recently, I've also had a reel go viral, though I'm not currently focusing on going viral or growing rapidly; my main aim at the moment is to serve the community I've built.

'Close your
eyes and try to
envisage who
is consuming
your ... content'

MONETIZING YOUR FOOD CONTENT

There's no shame in wanting to earn an income doing what you love. Whether you wish to work with brands as a food content creator like Mary (@flouringkitchen, page 80), or sell your own food, books and other products like Katie (@katies_little_bakery, page 38) and Todd (@turnipvegan, page 50), once you grow an online audience who are obsessed with your food content, the sky's the limit! Now let's explore all the monetization options available to you.

AFFILIATE COMMISSION

If there's an olive oil you swear by or a spatula you can't live without, you can earn an affiliate commission by wholeheartedly recommending it to your audience. Many major online retailers now offer affiliate programmes, and through your link-in-bio, your highlights and your stories, you can point your community in the right direction.

SUBSCRIPTIONS

Subscriptions are the VIP lounge section of your social media account, where you offer the people who adore your food creations the most, the opportunity to obtain new and exclusive content for a small monthly subscription fee. You can offer subscriptions on Instagram and TikTok, as well as on a third-party platform like Substack.

DIGITAL PRODUCTS

Unlike subscriptions, for which you need to create new content continuously, with digital products you do all the work upfront once and then sell that product again and again and again. Your digital product can be an ebook or anything else your audience would love.

USER GENERATED CONTENT CREATION (UGC)

If content creation is your jam and you'd like to work with brands, not as an influencer but as the person behind the camera creating content that brands can use on their own channels, then pitching yourself as a UGC creator is a great monetization strategy. The brilliant thing is that it doesn't require you to have a large audience or to step in front of the camera, but it does mean you must show evidence of your ability to create engaging and delicious-looking food content.

INFLUENCER CONTENT CREATION

If you enjoy creating content, have grown a loyal audience and wish to promote a brand on your TikTok or Instagram, then becoming an influencer means you can earn an income doing what you love. Payment will be dependent on your skill set, your audience size and reach, as well as general overall engagement levels. You can obtain influencer work simply by putting your content out there and being 'discovered', or through agencies who represent food influencers and pitch them to brands.

A COOKBOOK

For most foodies, publishing a cookbook is the ultimate goal. Not only is it very prestigious, but it can also be a great source of passive income. Though having a large audience isn't essential to getting a cookbook deal with a reputable publisher, it certainly does help! In addition, proven recipe development skills and a clear niche in which you are an authority will make you a very attractive cookbook author to work with. Quite a few creatives in this book, including Simone (@zaynesplate, page 130) and Nisha (@rainbowplantlife, page 98), have published cookbooks, so be sure to check out their tips and they could lead you in the same direction.

ONLINE COURSES

One of the most lucrative ways to earn an income through your food content creation is by offering an online course. It is quite a big undertaking to set up, run and market courses, but if you have a clear niche you can teach in and a sizeable audience, then it is worth looking into. From pasta or bread making to food photography and food content creation courses like the ones I teach, honestly, almost anything goes! Simply choose a topic you're passionate about, skilled in and known for.

A note of caution: focusing prematurely on monetizing your food content can backfire. Don't get me wrong — wanting to thrive financially as a food content creator or food photographer is an admirable goal, but if making money is your number one priority from the outset, rather than a genuine passion for food and a commitment to serving your community, people will be less than impressed.

TikTok:
@crowdedkitchen
453K

Instagram:
@crowded_kitchen
1.1M

Facebook:
@crowdedkitchen1
517K

Everything is delicious!

We didn't want to narrow down our food content too much, so despite not fitting neatly into any one box, we focused on getting our visuals just right to help us stand out. In the early days of blogging and Instagram, that meant creating impeccable food photos – we put a ton of effort into getting them to look as professional and droolworthy as possible. This in turn allowed us to grow pretty quickly in those first few years.

Our set-up worked for us, until it didn't anymore, and after being stuck at 210K followers on Instagram for two years, we decided it was time to adjust and adapt our approach. We stayed true to the principle of sharing everything we felt was delicious, but ensured that we focused more on sharing our recipes via video, rather than photo format. We also decided to include a recipe in each and every caption, moved away from capturing content on our professional cameras, and instead filmed everything on our phone – all shifts that people really appreciated. So, whilst the type of recipes we shared stayed the same, the way we were sharing them with our audience changed and, best of all, our new approach worked a treat and we grew our audience exponentially!

As time has gone on, the fact that we offer a wide variety of food content – from drinks recipes, which perform especially well for us, to vegan and vegetarian dishes, easy desserts, and classics such as burgers and fries – has actually worked in our favour and made us unique within the food space. The important thing for us has been to move with the times.

Things within the food content creation world are always changing and it's been important for us to stay true to our mission of sharing everything that's delicious whilst also embracing change.

HOW IT ALL BEGAN...

...We started our blog in 2015, and initially Lexi shared recipes of what she was eating as a college athlete, but once she graduated and moved back home in 2017, we decided to change direction, sharing instead a multitude of recipes for everyone. We rebranded to Crowded Kitchen and have been creating content full-time ever since. Our growth was exponential at the start, and we reached 100K followers within just two years. Thereafter, our growth was slow but steady, until things completely ground to a halt. That is until the spring of 2023 when we doubled our audience on TikTok and Instagram. It's been wild!

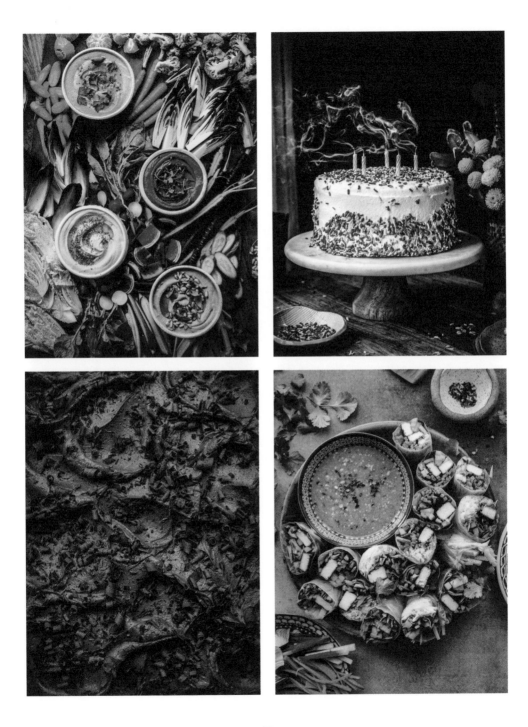

Develop a viral recipe

Developing viral content came after lots of experimentation and self-reflection. Once I realized that short-form video content allowed me to be more expressive whilst connecting with people and bringing them value, I went all in. I experimented for a couple years to then find my own creative style and voice in this space and that is what led to developing the viral date bark.

Dates have a special meaning to me and my grandma. What I love about them is that on their own they're ok, but once you combine them with nut butters and crunchy toppings, they completely transform, and eating them becomes an absolutely magical experience. I feel my passion for this unique dried fruit really resonated with my audience and I could see that my date recipes were the most popular.

When creating recipe content, ask yourself: how can I improve something people love? Focusing on taste, convenience and fun are essential components. Furthermore, creating something that's just that little bit different, customizable, fast and accessible gives a recipe an even greater chance of going viral. If people have the ingredients for your recipe in their cupboard or can quickly hop to the shop and find everything they need to recreate it, it's much more likely to be popular. Finally, if a recipe looks intriguing and enticing and you're able to use a trendy ingredient, you've got a formula for success.

Be sure to play around with ingredients and recipes that you genuinely love yourself. I feel proud of my viral recipes; they've been instrumental to my growth and it's been a blast seeing them take on a life of their own and bring people lots of joy.

HOW IT ALL BEGAN...

... I started my Instagram in 2017. I was consistent and able to grow my audience to about 10K followers. However, everything slowed to a near halt when I went travelling and couldn't post as regularly. Things changed when Instagram Reels and TikTok came along. I loved the creative freedom short-form video content offered me, and posting consistently didn't feel like a chore anymore. My passion and dedication led to several recipe reels going viral, with my date bark getting more attention than I ever could have imagined. As a result, I grew my community by more than 200K in 12 months and was able to turn my passion for food into my career!

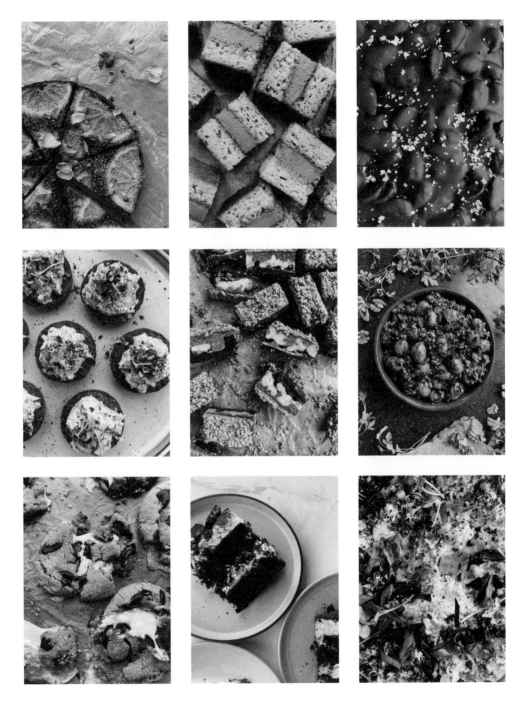

CAMERA ANGLES TO PLAY WITH

As food content creators we never want our videos or photos to be boring! That's because if our audience feels even a pinch of boredom whilst engaging with our content, they are much more likely to take their attention elsewhere. Considering the fact that attention is the ultimate currency for food content creators online, you want to do all you can to keep even a semblance of boredom at bay.

The ingenious techniques used by the food content creators featured in this book are essentially all about capturing and keeping people's attention, and playing with your camera angles is one way to ensure your food content is as attention-grabbing as it can be.

Here are a few camera angles to include in your food content that will keep your audience hooked for longer and keep them coming back for more!

The bird's-eye perspective

This is such a popular angle within the food space and it's so easy to see why. If you're sharing a food photo, this perspective allows your food to look its best and your composition and food styling skills to truly shine. There's nothing quite like it.

If you're sharing a food video, the bird's-eye view is great for showing intricate cooking and prepping methods as well as an awesome angle from which to share the final dish. Almost no other angle makes food look better!

The close-up

Though a close-up capture can be from any angle, essentially, the idea is to give viewers a sense that they're right there with you, almost able to taste the food. It's an intimate perspective and great to use if you have little space in your kitchen and want to draw people's awareness to the food, its textures and colours. The close-up angle is used so well by Mehma (@canyoucookuk page 86) who shows just how eye-catching and droolworthy it really is.

The wide shot

Taking a wider angle view, allows your audience not only to see your delicious food, but also you, the creator, and your surroundings. It gives a sense of context and place, which can be great not just for sharing restaurant content, but also if you want to make your recipe videos feel a little bit more personal.

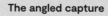

The angled capture

Placing your phone camera or DSLR at an angle allows your audience to get a clear viewpoint of your food. Similar to the bird's-eye perspective, the angled capture is also great for showing off important steps within a recipe. I'd absolutely recommend trying this one out.

'the idea is to give viewers a sense that they're right there with you...'

If you're filming on your own, your best bet is always to use a tripod to keep your film footage shake-free and crystal clear. However, if you're growing in confidence and ready to add a layer of complexity into your food videos, why not explore building in moving content?

For moving content to be beautifully eye-catching, be sure to keep your camera or camera phone stable as you slowly move over your food — ideally your final dish. A gimble or even a selfie stick can be fantastic here as it avoids excessive camera shake. That said, a steady hand can also do the trick.

+ TOP TIP

Many video editing apps have movement options built into them, including zooming in and out of static images as well as zooming in and out of video content. Using video editing apps can allow you to add movement into your short-form videos retrospectively and is ideal if you're hand modelling in your own food content and therefore don't have your hands free to move the camera around whilst filming.

Romanticize your life

I love food photography, and sharing my content on Instagram was a way of drawing awareness to my work. But with the introduction of Reels, my photo posts were penalized in favour of videos, so it was obvious to me that I needed to learn to share my content in video format to regain that visibility.

When I started making food videos I struggled to translate my vision and didn't have a clear idea of what my style should be. There were several people I felt inspired by, and loved how they filmed their reels, but I always thought I should remain faithful to my photographic style, which was all about light, colour, harmony, richness, elegance and grace. These key components are what I look to create in my food photos and also try to bring to my video content.

In my food videos I use what I have around me. I'm happy that what I create is perceived as romantic and elegant. I think this style works because people like to dream, they like to be transported into a fairytale dimension where even the difficult seems easy. I have to say, though, nothing about making these types of food videos is easy; every single clip is carefully composed and considered. In order to create a dreamlike look, nothing is left to chance, and I also have to prepare, cook and keep the room I film in clean whilst I'm making the video.

Sometimes I want to simplify my videos, eliminate many of the intricate details and speed up the process, but I know that that would betray my way of telling the story and portraying the romantic beauty of life and food, so I gather my strength and continue on this path.

HOW IT ALL BEGAN...

... I opened my Instagram account in 2016 because I wanted to establish myself as a food photographer. At first my follower growth was very slow, as I only posted occasionally. However, my engagement was very good. In the following years, my growth was slow but steady, and it's only in 2023 that I have doubled my audience, mainly as a result of sharing my food content in the form of highly curated reels, some of which went viral and brought me a fair amount of visibility.

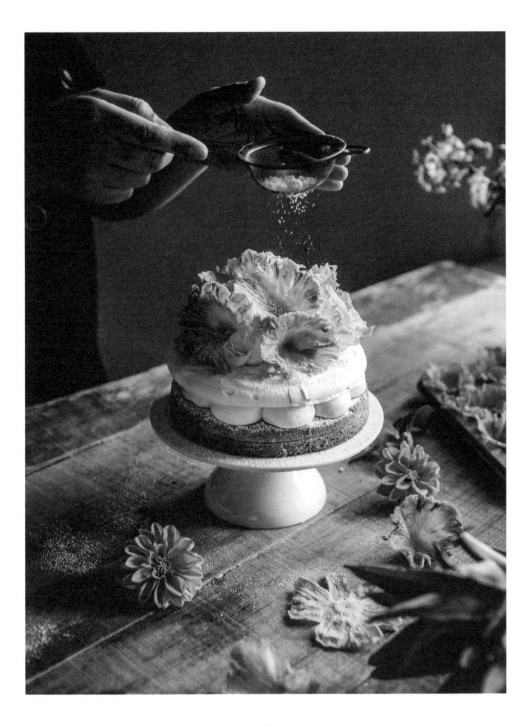

TIKTOK
@flouring.kitchen
314.3K

INSTAGRAM
@flouringkitchen
175K

YOUTUBE
@flouringkitchen
5.3K

In technicolour

When I started my blog and social media accounts, I followed a tried-and-tested method within the baking space, going all in on the monochromatic look, which included sharing lots of chocolate-based recipes! Then, in June 2021, with just 1K followers to my name, I made the decision to try and turn Flouring Kitchen into a flourishing online business.

When I looked at my social media and blog insights to date, I noticed something interesting: the more colourful fruit-based recipes – especially my lemon bakes – outperformed all my other content. The beauty of this discovery was that the feminine, colourful bakes allowed my personality to truly shine through, and also enabled me to stand out from the crowd, both of which were instrumental to my growth to over 160K followers on Instagram and 260K on TikTok in just two years.

To truly allow the colours of my bakes to pop, I started filming content on my DSLR camera and put a lot of time into finding the right LUTs (Lookup Tables – essentially filters or presets specifically designed to edit video footage), which further enhanced the look and feel of the colours in my reels and TikToks. In doing so, the freshness of the fruity ingredients I was using in my bakes was highlighted and earned me the nickname 'Lemon Lady'.

Before I share a recipe on social media, I really think about how the recipe will look. If there is anything I can do to make the recipe's colours stand out, I will. Embracing colour has been instrumental to my success – might it be the key to yours too?

HOW IT ALL BEGAN...

... I have always loved baking, so much so that when I graduated from high school I was considering going to culinary school, but friends and family advised against it. I wasn't confident enough yet to follow my heart and instead went to university, graduating in 2019 with a degree in agriculture and food science. I sent countless applications, but then COVID struck and finding a traditional job felt impossible. Add to that the birth of my daughter and I knew it was time to give my love of sharing recipes the dedication it deserved. Initially, I was a little shy about posting my creations, but by the summer of 2021 I was ready to prove everyone wrong and just went for it. And the rest is history!

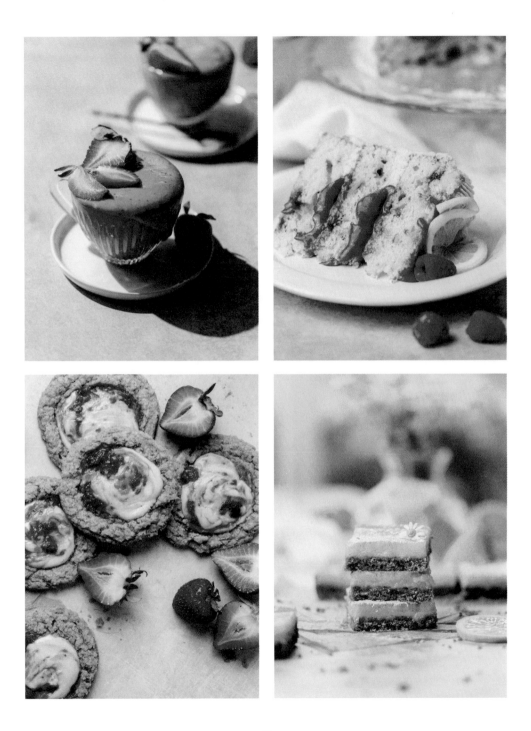

PERSEVERE, PLAY OR PAUSE?

What if you create food content to the best of your abilities, but it still isn't resonating with an audience? If this is you, let's explore which strategy you need to pursue next.

PERSEVERE

As you will have read in the feature by Jose (@jose.elcook, page 28), it's imperative to pursue your goals with vigour and not give up on them prematurely. Though there are of course a few exceptions, the reality is that achieving success on Instagram or TikTok simply takes time. Please don't judge yourself too harshly if your content doesn't immediately find an audience – instead, keep going, keep posting and keep persevering!

I appreciate that this is easier said than done, but have you noticed that perseverance is one of the few things everyone featured in this book has in common? No one stopped creating the food content they loved, even when things weren't going the way they'd hoped.

However, it does beg the question: how long should you persevere? Though there is no one-size-fits-all answer, a good ballpark figure to aim for at the start of your social media journey is a minimum of 60 to 75 pieces of published content within a six-month period – roughly three posts a week. That's because this frequency and consistency level is needed to fine-tune your skills, gain real traction and assess accurately if what you're doing is working or not.

Be sure to use your insights and stats on Instagram and TikTok to establish which content pieces are resonating most. Metrics such as likes, follows, shares, saves and engagement can help you gain clarity as to whether you're heading in the right direction. (Please note that you may need to have a business or creator account to access these statistics, so be sure your profile setting allows you to access this vital data.)

If there is no upward movement in any of these areas, despite posting consistently, here's what you could do next...

PLAY

If the content you are sharing isn't finding an audience, why not take that as an invitation to change course, get creative and explore new ways of telling your food story? Do so by staying curious and playful whilst experimenting with other content formats as well as different types of recipes. Continue to keep a close eye on your stats. Check in monthly to see which of your new content pieces are gaining traction and then create more of those. When you look at content creation as playtime, it can take the pressure off sharing your content and make the entire process more enjoyable.

PAUSE

What if you've tried it all: you've posted consistently for six months, you've explored new and fun ways of sharing your food, and people still aren't taking an interest?

Sometimes when you are feeling disheartened, it's almost impossible to see things clearly, to think strategically or approach your content creatively. In those instances, the best course of action may be to press pause.

Step away for a few weeks, give yourself the opportunity to get inspired or to simply process your disappointment away from the pressures of Instagram and TikTok. Then, when you feel good and ready, take a long, hard, honest look at what you've shared to date. Were you genuinely as consistent as you needed to be? Were you truly as creative as you could be? Did you really use your data or the tips in this book to plan your content strategically? My hope is that, after a necessary pause, you will find some areas to improve on and approach your food content creation with new-found vigour. You got this!

Breadilicious!

I believe that focusing on bread as your food niche on social media works because everybody has grown up eating bread in some shape or form; there's a strong cultural connection to specific types of bread that evoke childhood memories in all of us.

Bread is also visually stunning and a beautiful subject to capture; there's so much contrast between the crust and the crumb, plus it comes in a multitude of different shapes and varieties. It's a feast for the eyes. I see so much beauty in a well-baked loaf of bread, and once people start making their own bread, they too can appreciate how beautiful it truly is. Capturing the bread baking process and the final baked loaf is a joy, and I think the passion I feel for it comes through in the content I share, which has helped me grow an audience online.

Bread baking is something you can easily get obsessed with; the thing is, when you start baking, it's hard not to get seriously into it! And when you're learning to bake, having social media accounts that can provide information and resources is invaluable. It's for this reason that my account has become a real community hub for all things baking, which in turn has led to my growth on Instagram.

Baking an excellent loaf of bread is challenging, and if you can make the process easier for folk and inspire them to bake to the best of their abilities through the content you share, be it photos, short-form videos or captions, you're bound to find success online.

HOW IT ALL BEGAN...

... Shortly after the app launched in 2010, I opened an Instagram account, but I didn't understand it. Then, when Instagram started gaining popularity in 2012, I would post random everyday stuff. It wasn't until 2013 that I started sharing pictures of my sourdough loaves. At the time, sourdough was a niche topic and therefore growth was extremely slow. I posted daily for years without gaining much traction, but continued to share what I was passionate about and grew a small, loyal community. It was only when the pandemic hit in 2020 that things went crazy. My growth has stabilized since then, and that's ok. I simply want to serve the community I have in the best way that I can, and growth isn't my top priority!

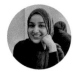

Up close and personal

Initially, my growth on Instagram was slow and it took me a good year to get to 30K followers. But that time wasn't lost; it was simply time I needed to understand what people were looking for on social media.

I noticed that people love recipes in which the food looks delicious and tempting as well as easy to make. Aesthetics are such an important component in capturing people's attention. By bringing my phone camera really close to the food, my audience can see all the colours and textures and get completely drawn into the recipe video. And by using good natural lighting – especially harsh sunlight – plus close-ups, I can make my food look as good as it tastes. To keep things interesting and varied, I work with a few different close-up angles, but always put my food, rather than myself, front and centre.

The other side of the story is that I'm naturally a very shy person and stepping in front of the camera to create food content just isn't for me, yet I still wanted to share my recipes because I knew that they could bring others joy. Focusing on the food I was cooking, and drawing people's attention to the recipe at hand through close-up captures, was a great way to share what I love in a way that I felt comfortable doing.

It worked, and not only have I had a number of videos go viral, I was able to grow over 70K followers in just two months. In addition, I've also built a wonderful online community – it's been an amazing journey!

HOW IT ALL BEGAN...

... I started a YouTube channel during lockdown in May 2020, when job opportunities were few and far between. I had recently got married and felt it was a great opportunity to use the extra time I had to share what I was learning in the kitchen with others who were in a similar life phase. I subsequently also opened Instagram and TikTok accounts and quickly noticed that both were gaining more traction than my YouTube channel ever did. Once I had a number of viral moments on Instagram, I let my YouTube channel go in order to focus on what was working on the platforms where I had the most reach and impact.

WHAT DOES CONSISTENCY LOOK LIKE? (AND HOW TO MAKE IT HAPPEN)

If there's one universal ingredient for success, it's consistency! Though Nadia (@travelandmunchies page 94) speaks on this point specifically, everyone mentioned in the book has been consistent in their food content creation; it's been an essential part of how they've built their following.

Perhaps you feel overwhelmed at the thought of posting more content, or are simply unsure how to make it happen alongside all of life's other demands. Maybe you've tried to be consistent in the past, but burned yourself out in the process and stopped posting altogether. If this sounds familiar, here are my top tips to ensure consistency becomes part of your creator tool kit.

Define what consistency looks like for you

Some of the talented people mentioned in this book are full-time content creators and posting daily is part of their job. Putting pressure on yourself to post as often as they do can therefore feel really overwhelming, so it's imperative not to compare your beginning to their middle or end. Instead, be honest with yourself about the amount of content you can realistically fit around your work, studies and personal life, and then create a content schedule accordingly.

To find your content creation sweet spot, start by sharing your content regularly for 2–3 weeks. Then assess how many weekly posts feel possible and energizing, rather than depleting. Once you've found a posting schedule that fits, commit to it for at least 3–6 months in order to see actual results.

Block out content creation time

If it's not in the diary, it's not going to happen! So be sure to block out time for buying whatever ingredients you need to create your food content, some time to photograph or film it, and further time for editing and posting.

Plan your content

I admit, planning doesn't sound particularly sexy, but it is essential if you want to share high-quality content consistently. The alternative? Frantically trying to create food content last minute to ensure you meet your weekly posting target. The consequence? Not posting the calibre of content you'd like to, which in turn can negatively impact engagement and reach.

To avoid feeling you have nothing to share, why not sit down at the end of each month and plan your content pieces for the following month? Give yourself an hour or two to come up with recipes you'd like to test, restaurants you'd like to visit, new content ideas you'd like to explore, and so on. Using a content calendar can be a helpful tool when planning your content. You can download my printable content calendar here: thelittleplantation.co.uk/food-famous.

Use multiple cameras

If you're filming recipe videos, it is not essential, but certainly incredibly time efficient, to set up not one but two cameras as you're capturing your content. It means you film scenes from multiple angles at the same time and can use the additional footage in your recipe reel – the change of angle will increase your pacing and make your transitions more interesting. You can also repurpose the additional footage on other platforms, for future compilation videos, or in your Instagram or TikTok stories. Footage from your second camera is sometimes referred to as 'B-roll', which can further be used as standalone content for a behind-the-scenes type video or a quote overlay video.

'...once you're in creation mode, it just makes sense to produce as much content in one go as you can.'

Batch your content

Rather than going to the supermarket to buy ingredients for one recipe, why not shop for several recipes in one go? If you've planned your content for the month, you know exactly what you're creating, so prepping for multiple content pieces simultaneously will save you so much time.

And whilst you're at it, why not film and photograph multiple recipes in one day, too? It's time-efficient to pour your energy into one specific task rather than task jumping, which reduces productivity. In addition, once you're in creation mode, it just makes sense to produce as much content in one go as you can.

Repurpose your content

Repurposing your content is a great way to stay consistent, especially when you've got nothing new to share. Though platforms like Instagram and TikTok will always favour brand-new content pieces, repurposing content that did really well previously, or that feels exceptionally timely, is a fantastic way to stay committed to your content schedule and grow your audience, whilst at the same time giving yourself a content creation break.

If you do repurpose content, be sure to leave a gap of at least three months between when you first posted the content and when you repost it. Also explore whether a slightly different edit or a newly trending song can make your food content piece even better.

+ TOP TIP

Consistency requires effort. Not everyone wants food fame enough to put in the work required – but I'm confident that you will!

TIKTOK
@betweenspoonfuls
945K

INSTAGRAM
@betweenspoonfuls
615K

YOUTUBE
@betweenspoonfuls
278K

Play with your food

I have always been interested in food art and fascinated by how chefs could plate their food like artwork you could display in a museum. In particular, I am so inspired by the Japanese character bentos or charaben, and how elaborate and intricate these delicious lunch boxes can be.

Making food art evokes so many positive emotions in people. Having this impact has been key to building community and finding success as a food content creator. I often get messages and comments from my audience saying that my content has brightened up their day. These interactions motivate me to try my best to bring more happiness into the world.

I'm a millennial, and we are known to be nostalgic. I love tapping into that nostalgia affinity and will reference characters from old movies and video games in my food art. This helps me connect with people with the same interests by evoking similar childhood memories. When people see my content, they think of precious memories with their friends and family and, in turn, will reshare my content or tag people in the comments. This engagement helps push my content in the algorithm and allows me to have incredible reach worldwide.

Creating food art can be time-consuming and requires patience and lots of imagination, but having that attention to detail can help you stand out.

It's essential not to box yourself in too much and to keep creating things that excite you and your audience. Look for inspiration, create mood boards on Pinterest, and use recipes from your culture so people can learn more about you.

HOW IT ALL BEGAN...

... I started an Instagram account around 2017 and focused on travel content, but a few months in, I realized that creating food content was more authentic to my daily life. With the pandemic in 2020, I found this inner creativity in the kitchen that I finally had the time to nurture and explore. First and foremost, I create authentic content that I enjoy making on my own. Stay true to yourself and show others your authentic self, and success will follow.

TIKTOK
@travelandmunchies
229.7K

INSTAGRAM
@travelandmunchies
306K

Consistency is where it's at

Please don't feel discouraged when recipe content you create doesn't do as well as you'd hoped. If you are regularly posting reels or TikToks of high quality, people will eventually come!

I was posting four to five short-form recipe videos a week, which was a lot of work. My growth was slow and steady, but I was ok with that as creating recipe content felt like fun. Then, in 2020, one of my content pieces went viral, growing my audience from 16K followers to 100K almost overnight. I believe that creating consistently prior to my viral moment really paid off – people found so many high-quality food videos that they decided to like, follow and stay.

Once you have a piece of content that does really well it's important to seize the moment and continue to post as consistently as you were when you went viral. This strategy allowed me to continue to grow exponentially for months afterwards. It's crazy, but consistency really is the magic wand that allows your content to have a huge impact and your social media accounts to grow quickly.

Consistency doesn't mean you have to post daily. Four posts a week is ideal, though you can post two or three recipe videos a week and still experience immediate growth. As long as the videos are of high quality, you can build a large audience.

Look at content creation as a priority. Essentially, it is a time management game, so be sure to set half a day aside for each recipe video you want to make.

HOW IT ALL BEGAN...

... I started my Instagram account in 2014 in order to share images of restaurants and cafés I discovered following a move to Montreal for my undergraduate studies. It was very casual and purely for fun. A few years later, I got a part-time job at a food media company, creating written restaurant reviews and images for them. When the pandemic happened in 2020, they shifted gear and asked me to create recipe content instead. The more I posted, the more my content attracted the attention of brands, and with the advent of video-based food content, even more brand deals came my way. I'm in medical school now, and brand collaborations as well as freelance food content creation for clients like the New York Times help fund my education. Food content creation hasn't just been profitable for me; it's also so much fun!

FINDING YOUR STYLE

If you look at the food landscape on TikTok or Instagram, you'll notice that there are a few distinct styles that are emerging as both popular and integral to our experience and understanding of food content online. Though there's always space to try something completely different, if you're starting out, why not tap into one of the styles that have already proven to be a formula for success? Remember, you can always adapt a style and make it your own once you find the one that speaks to your personality and audience the most. Here are the different styles that are currently all the rage.

DYNAMIC

The core essence of this approach is speed. There are quick cuts and unexpected transitions, often accompanied by ASMR and/or fast-paced music for extra impact. This style works incredibly well because it keeps the viewer hyper engaged; there's so much going on, you feel as though you'd miss something fun and exciting if you merely blinked. A creator who really nails this dynamic approach is Victoria (@pigtoriasecret, page 140).

CHARISMATIC

In the charismatic approach, the creator is as important as the food, which is why they feature in each and every food video. This approach is powerful because it creates a strong bond between community and creator and instantly gives the food content a personalized and unique flavour. Creators who use this style are often seen trying the food and have a perfect balance between trust and loyalty, both of which they take incredibly seriously. A creator who is brilliant at this approach is Shivesh (@shivesh17, page 128).

RELATABLE

Like the charismatic approach, in this style the creator often features heavily in their food videos, but the important aspect is that they keep the voiceover, food and video style super informal. The voiceovers feel less scripted, the food is quick and easy to prepare, and the video itself is often clearly filmed on a handheld phone. It makes the audience feel like they are right there with the creator, and getting an uncensored glimpse into their kitchens and lives. Renu (@hey_renu, page 122) is a master of this style.

PROFESSIONAL

When short-form video content took off on TikTok during the pandemic in 2020, it was all about the relatable style. This approach still very much works today, but there are now a few food content creators who have carved a different path for themselves, filming on professional cameras and editing to the highest of standards, thereby creating short-form videos more aligned with Hollywood blockbusters than the snappy Instagram recipe reels we've all grown to know and love. Someone who places great value on that professional look is Betty (@stemsandforks, page 12); do check out her work, it's unbelievably inspiring.

NARRATIVE

This style is all about telling compelling stories, which may or may not be connected to the food content shared in the video. Here, the focus is on a thoughtfully put-together and emotive script that either gives the audience a glimpse into the creator's personal life, touches on current affairs, or asks compelling questions, perfect for self-reflection. The creator best known for pioneering and mastering this style is Joanne (@thekoreanvegan, page 58).

INSTAGRAM
@rainbowplantlife
823K

YOUTUBE
@rainbowplantlife
1.21M

Be on multiple platforms

I've been on social media since 2016 and things have changed so much during that time. From sharing photos to moving into short-form video; from algorithms that allowed for easy growth to ones that made growth slower – I've experienced it all. Therefore, both as a way to keep building my community and honour my mental health, it's been vital to ensure I'm not putting all my content creation eggs into one basket. I didn't want to feel like I was always at the mercy of yet another algorithmic change, and being on multiple platforms has helped me feel more in control of my food content creation business.

I'm not suggesting you spread yourself too thinly. Instead, think about which platforms make the most sense to you. Which ones play to your strengths? Which allow you to connect to the people who need your content the most? And which make the most sense for the type of food content you want to create? If you love being in front of the camera, a platform like YouTube can be great. If you're a talented writer, start a blog in addition to a social media platform like Instagram. Strategy matters.

Being on multiple platforms allows you to show more and different sides of your personality, which in turn helps to build community, increase engagement, create a sense of loyalty and instil trust. Consistently creating content – and especially longer form content – can also help to give your audience a fuller picture of who you are.

If you don't diversify your platforms, you are more vulnerable to certain changes. Diversification enables you to build a long-term strategy, rather than needing to pivot all the time. It can also allow you to make food content creation your full-time job.

HOW IT ALL BEGAN...

... I started in 2016, when I was still working full-time as a lawyer. I disliked my job and used social media as a much-needed fun and creative outlet where I shared recipes. Though I never intended to turn food into a career (I hadn't even heard the term 'influencer'!), I gained some traction and within a year was able to leave my job and move into working in the food space full-time. My audience growth has always been steady, but once I expanded my content beyond Instagram and leaned into video content, it really took off!

TIKTOK
@flourandgrape
45.4K

INSTAGRAM
@flourandgrape
120K

Adjust and adapt

It's easy to get stuck into the day-to-day tasks of running a restaurant, but after years as a restaurateur I've come to appreciate how important marketing is. When I started out, we used traditional media, which is crazy expensive. Social media is a much more affordable way to spread the word, so it made sense to give it a go.

I hired someone to take professional photos of our food and posted the images onto social media. It worked. But as platforms like Instagram changed, and others like TikTok emerged, I had to keep evolving and experimenting. I moved from posting predominantly pictures to focusing on sharing more visually engaging video content, and eventually decided to hire an in-house creator; that's how important it was to me to get the word out there about the food we create.

As the food space online has become more saturated, it's been important to adjust and adapt the type of video content we share too. Now we focus more on the pasta making process, rather than just the final plated dish. We do multiple takes, create hours of footage, are ruthless in our editing process, all to ensure our content is attention grabbing and engaging, whilst still retaining its authenticity.

Now, at the core of everything, is our food. It needs to be high quality, it needs to be super tasty, and it needs to be real; if not, no social media marketing tactics will work long term. As you adjust and adapt to the ever-changing social media landscape, you'll need the energy of a good product behind you. It's what will fuel you and what will keep people coming back for more.

I wish I could say there's one thing I did that led to our success online, but there isn't just one thing. It's about investing time, energy and passion, and in some cases also money, into finding what works and being open to the idea of continuously evolving how you communicate your love for the food you create.

HOW IT ALL BEGAN...

... After running a bar and restaurant for a few years, I wanted to find new ways to bring more customers through the door. I hired someone to take images to share on social media and it worked. Then, when I opened the doors to Flour & Grape in 2017, I once again looked at social media to publicize business. Growth was slow and steady, but in 2023 things just exploded as we finally found exactly what worked for us.

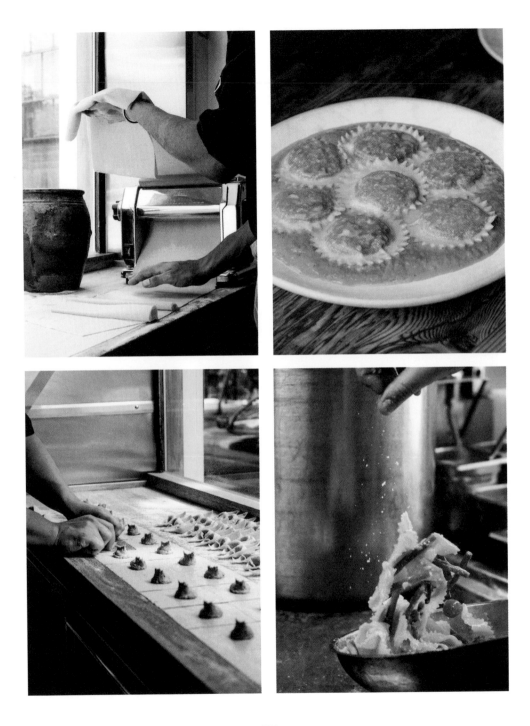

THE BEST RESTAURANT PHOTOGRAPHY AND VIDEOGRAPHY TIPS

Are you going to a gorgeous restaurant and want to share the experience with your online community in a short-form video? Or do you wish to establish yourself as a restaurant photographer and need some top tips to ensure you always get the best possible images? Then look no further, as my top restaurant photography and videography tips are below...

Visit the venue

Ideally, you should always visit the venue prior to a shoot, to establish lighting conditions, layout, wall and table colours, and anything else that might impact your content creation process. If that's not possible, study the restaurant's social media account to establish where the best spot in the house is to capture the images and video footage you want.

Lighting

If you're using natural light, be sure to sit close to a large window. If this is not an option, bring adequate artificial lighting with you to obtain the best possible shots. For short-form video content creation, a portable LED light will do the job perfectly. For high-quality food photos, professional artificial lights, light stands and softboxes will be required (see page 33).

A multitude of angles

Capture the food from a multitude of different angles, whether you're filming a reel or shooting images for a restaurant menu, to ensure your content is fresh, varied and exciting. Try to include bird's-eye perspectives, straight-on shots, angled shots and close-up shots, as well as wide shots that show the interiors and ambience of the venue (see pages 75–77).

Visit during quiet times

For professional restaurant shoots, I like to arrange to photograph when the restaurant is closed to the public, or super quiet, for example, at the very start of a service. It means I'm not interfering or in the way when the restaurant needs to attend to paying customers, and I'm not adding unnecessary pressure for the already busy chefs.

When capturing short-form video content for Reels and TikTok, I also like to visit when the restaurant is not too busy; that way I can get the best seat in the house and capture great interior content too.

Familiarize yourself with the menu

Before your visit, check out the menu to see which dishes will be the most beautiful to capture. Is there anything that has a show-stopping element, like a silky sauce that can be poured over the food, or colourful garnishes that will look ace once captured on film?

TIKTOK
@kalejunkie
591K

INSTAGRAM
@kalejunkie
1.7M

YOUTUBE
@kalejunkie
87.5K

It's trending!

I had been sharing recipe content for a few years when TikTok emerged as a platform. I was eager to continue to evolve as a food content creator, and curious to discover new trends within the food world in order to push myself creatively by giving different types of food content a try.

My curiosity led me to experiment specifically with food trends I found on TikTok. Recreating trending recipes wasn't a growth strategy at all in the beginning, but just the result of my curiosity taking over!

Then, in 2022, I shared a produce tip on Instagram, which I'd discovered on TikTok where it was trending: how to keep your berries fresh in the fridge for two weeks. That video was my first viral moment on Instagram.

As I like to stay on the cutting edge of what's new, I've continued to bring viral food trends and recipes I find on TikTok over to Instagram. I don't only share trending recipes though, I mostly post recipes that I create myself. It's the mix of both that people especially love.

As a result of finding and sharing food trends, I've had numerous viral moments and lots of growth. My audience really likes that I keep them in the loop and share my honest reviews of trending recipes and food hacks. It keeps my work interesting and fun and takes away the pressure of having to always create brand-new recipes from scratch!

HOW IT ALL BEGAN…

… I started my Instagram in early 2015, when I was still working full-time as a lawyer but feeling unfulfilled in my job. Instagram was a creative outlet and I would post what I was eating, as I was recovering from a 15-year battle with an eating disorder that no one knew about. As I became more open about my struggles, I started to grow a following and also realized how much I enjoyed creating recipe content. Despite some bumps along the way, my growth has been organic and consistent, almost from the outset. That said, I noticed a real surge in followers in 2022 when I started sharing viral trends. On one occasion I grew 200K followers in just one week! And things have gone from strength to strength ever since.

Be intentional

Initially, I was posting without much thought or strategy, as and when the mood struck me, focusing on restaurant visits I'd enjoyed, as well as the occasional recipe. Consequently, my growth was very, very slow.

Even after the introduction of Reels, and despite shifting my focus to sharing solely recipe videos and having a viral moment, my growth was slower than I'd hoped, considering how many hours I was putting into my food content creation.

Things started to change when I allowed myself to be a little more experimental on TikTok; I felt freer there than on Instagram, and could post different types of content without feeling that everything needed to look perfect. Consequently, I went viral on TikTok multiple times with food content I never shared on Instagram.

This experience allowed me to obtain important data about what was resonating with my community and why. I noticed that the videos that were performing best were clearly aimed at people who already loved to cook, but wanted to improve their skills. This meant that when I did voiceovers where each step of the process was explained, my views went through the roof, compared to the ASMR videos that didn't address my audience's need for detail. It made me realize

that I'd never truly considered my audience and what they actually wanted from me, nor why they'd started following me in the first place.

As I was looking at the stats of food videos that had done well, it dawned on me that I'd not had a plan or strategy and I realized this was the missing piece. So I thought about my mission and vision, who I was trying to reach and what they needed from me, how I could create a brand look for my content, and so on. It changed everything. It's so important to be intentional about what you're sharing and why; it made a huge difference to my growth and it's bound to make a difference to yours too!

HOW IT ALL BEGAN...

... I started my Instagram account in early 2017, when I moved from Spain to Oxford in the UK. At the time, I was posting under a different handle (@whatscookingoxford), where I shared photos and reviews of restaurants and cafés. Growth was very slow, and by the time I left the UK in January 2020 and returned to Spain, I had around 5K followers, at most. Then when I became much more intentional about my content, my following grew exponentially!

DIFFERENT FORMS OF SELF-EXPRESSION

Community and creativity are central to the fabric of what makes up Instagram and TikTok. It's their commitment to both of these principles that has allowed them to gain such popularity and become true hubs for food creators across the globe. Both TikTok and Instagram have understood that creatives – including those sharing their food – need different ways to express themselves and connect with their community. Consequently, they provide a plethora of formats via which to share your food story online. Each method serves a different purpose, so let's take a closer look.

STORIES FOR RELATABILITY AND TRUST

Unlike grid posts, stories are less about reaching a new audience and growing a following and more about connecting more deeply with the community you've already built. Stories tend to have an informal, relatable vibe and are great for behind-the-scenes content that fosters a deeper sense of trust with your audience. Story posts, which can be photos, text or videos, are great as complementary posts to those you share on your main grid.

LIVES FOR CONNECTION AND COMMUNITY

Lives allow you to broadcast yourself live to your audience on TikTok or Instagram. Only a very small percentage of food creators utilize the live feature, so if you do decide to use it, it's a great way to catch people's attention. It does take some courage to stand in front of the camera, but it's such a powerful way to show up raw and authentically. Lives are a wonderful way to connect with your community in real time and to show the real you!

GRID POSTS FOR REACH, ENGAGEMENT AND GROWTH

The purpose of posting on your grid is to provide value to the audience you already have, and to attract new followers too. That's why posting consistently on your grid like Nadia does (@travelandmunchies, page 94) is paramount if you want your food to be famous.

+ Short-form video is the best growth tool on all social media platforms at the time of writing, so needs to be integral to your strategy. Short-form videos are fantastic for sharing recipes, educational content, behind-the-scenes clips and personal food stories.

+ Photos are a fabulous way to slow down the pace and draw people's awareness to a specific recipe or your unique food-styling skills. Many creators use photos to round up their week and keep their community in the loop of all that's going on in their life and their kitchen, often sharing multiple images in one post. Photo posts don't tend to lead to significant follower growth, but remain surprisingly popular on both Instagram and TikTok.

+ Text posts may seem boring and not applicable to food creators, but you'd be surprised. Text posts, often presented in carousel format – a grid post that consists of multiple images or short video clips or both, can be highly educational and, if done well, super eye-catching. They are easily shareable and can be great as part of a thoughtful growth strategy.

TIKTOK
@Chef__pier
1.3M

INSTAGRAM
@Chef__pier
2M

YOUTUBE
@Chef__pier
3.8K

It's all about that feeling

I started out making short-form recipe videos with a slightly silly touch because I noticed that there was a gap in the market. You see, in the chef world, everyone tries to be serious, and sometimes even angry. So, in order to stand out, I took the opposite approach!

As time went on, however, I changed my format and stopped posting recipes all together, as I realized that the content that focused on making people laugh in my role as a chef did better than any recipe. There was a funny video where I was flipping a crêpe; it took me just 20 seconds to make, but it went viral, got millions of views and brought me an endless stream of new followers. I knew I was on to something, so I just did more of what worked.

On the surface of it, my content is funny and entertaining, and undoubtedly both of these things matter when it comes to growing an audience online, but what's underneath it all is how you and your content make people feel. Sure, the food in your videos needs to be good, but it's simply not enough to make you stand out; there has to be something more, and that 'more' is the emotion you evoke. In my case, the feeling I create in my audience is happiness, and that's what they follow me for.

There are lots of people who create delicious recipes, but that segment of the market is so oversaturated. By being different and bringing people joy in my role as a restaurant chef, I grew a really large audience because, essentially, I had little to no competition within the niche I had carved for myself. And I believe that by focusing on feelings, you can do the same.

HOW IT ALL BEGAN…

… I'm a trained chef, and when COVID hit in 2020 and all the restaurants shut down, I decided to start my TikTok and subsequently my Instagram account. I always felt that having a strong social media presence was paramount to growing a successful business as a chef and restaurateur, and with the extra time on my hands, I finally had the energy to pour into my own channels. Over the course of three years, I managed to grow both my TikTok and Instagram to over 3 million followers and counting, and am now looking forward to opening my own restaurant in the near future!

'what's
underneath
it all is how
you and your
content make
people feel.'

Keep it fresh!

When I decided to grow my online food accounts, I knew that creating content at scale was going to be vital. I'd been to a few meet-ups with other content creators, and that was the thing people talked about the most: the need to post new content, often!

But after 10 months of posting brand-new recipes daily, I realized it's not just about posting every day, it's also about keeping your posts fresh and exciting. There's only so much you can do with the same style and the same approach to food content creation before it becomes stale. You need to keep evolving and freshening up your content in order to attract a new audience, in addition to the one you already have.

For me, the need to grow as a food creator is as much about building my audience as it is about continuing to try and find my own unique voice. When I started, I had a rough idea of what I wanted my food videos to look like, but I also think it's cool to review your approach as you establish yourself and become more confident. So much has changed since I started posting, and it's important for that evolution to show in my work.

Posting new content as often as you can might not get you to where you want to be straight away. It took me four months to gain any traction at all. But eventually there's a compound effect, and then, with a willingness to continuously refresh the look and feel of your food content, the sky's the limit!

HOW IT ALL BEGAN…

… I went vegan in 2020 and decided to start Prunchme as a joke account, to share what I was eating when out and about. The only people interested in my content at the time were friends and family, but when I started sharing recipe content, things picked up. I did feel a pinch of imposter syndrome, however, so I went off to culinary school in the UK to become a trained chef. When I returned home to Dubai in January 2023, I felt reinvigorated and decided to go all in on recipe content creation. I hired a team and created food content at scale. Initially, I didn't see results, but I kept going. Then, suddenly, one of my reels blew up, and then the next one did too, and the one after that… It's been incredible.

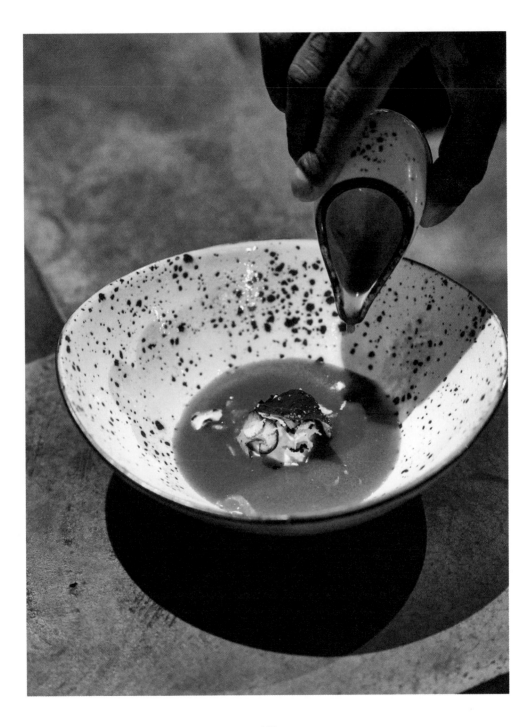

MY TOP FIVE DRINK STYLING TIPS

Though food undoubtably rules social media, drinks — both alcoholic and non-alcoholic — are a much-loved focus for food influencers and food photographers too. In fact, mastering both food and drink content creation could give you a real edge. With that in mind, I'm sharing my top five drink styling tips for when you're attempting to capture stunning images at a gorgeous bar, or film an irresistible mocktail on TikTok.

Use gorgeous glassware

+ **Coupe glasses** have an elegant, elevated shape that instantly suggests a special occasion.
+ **Ribbed and textured glassware** are not only easier to photograph than smooth glassware, they're also visually more interesting and eye-catching.
+ **Colourful glasses** can truly liven up an image and bring your colour story together – and they're also just so much fun!
+ **Trendy glasses** – from glasses shaped like mushrooms to those giving Art Deco vibes, you need to make sure you're in the know. Keep an eye on your favourite food content creators and see what glassware they're using, as this will give you insight into what's fashionable right now.

Good-looking garnishes

Garnishing your cocktails will take your drinks photography and videos from good to great. Garnishes can include an array of fruits and vegetables, salty, spicy, sugary or herby rims, and edible flowers, to name but a few! Can you think of any more you'd like to play with in your drinks photography and content creation?

A little splash of drama

Drinks look much more interesting when they include a drop, splash or pour. The drama this adds to your image or video is not only impressive, but also captivating. I'd invite you to have a go with different techniques.

Light

As discussed on pages 32–33, light is the starting point for all visual arts, and drinks photography is no exception. Be sure to be thoughtful about your light direction, reflections, and other lighting needs.

Tools of the trade

If you want drinks to be the focus of your photography or content strategy, I'd highly recommend adding the following to your tool kit.

+ **Straws** make wonderful accessories for smoothies and milkshakes.
+ **Cocktail sticks** are invaluable for styling a Bloody Mary or tropical cocktails.
+ **Tweezers** allow you to work with more precision, especially when arranging your drink's garnishes.
+ **Syringes** can be used to gently add liquid, or remove some from a glass.
+ **Cocktail shaker.** As mentioned on pages 24 and 55, your content will be more attention grabbing if it's action-packed or tells a story. Cocktail shakers can introduce both into your videos and photos.
+ **Ice cube moulds or fake ice.** Ice cubes are having a moment; gone are the days when they were awkwardly shaped rectangular cubes. Now you can find them in all shapes and sizes, adding so much interest and personality to your drinks content.
+ **Coasters.** Similar to glassware, coasters introduce personality and textures and can tell your community so much about you and your style!
+ **Brush.** If you'd like to decorate the side of your glassware, using a brush to distribute lemon juice, to which salt, sugar or spices can subsequently attach themselves in a particular pattern, allows you to work with precision.

TIKTOK
@ranasmagg
375.3K

INSTAGRAM
@ranasmag
1.9M

YOUTUBE
@ranasmag
1.7K

Be yourself

After trying to capture my recipe videos from a static, top-down angle only, I decided one day that I wanted to be more creative, more expressive, more ambitious and more me. After researching how I could make my videos better, I implemented what I'd learned and also chose to step in front of the camera, because how could a recipe video fully capture my personality if I wasn't in it?

I am an artist and I really wanted my recipe videos to feel artistic. I think carefully about the music I use, the pacing, the angles and so on, so that the content feels like a reflection of what's in my heart. I don't try to be someone I am not, and instead I wear my heart on my sleeve. Interestingly, since I made my food content feel more authentic and personal, my videos have gone viral multiple times. I've also received so many messages, especially from women who feel inspired by my willingness to be authentic and real, and my Instagram and TikTok have grown really quickly.

It's hard to be authentic – it takes confidence – but remember, you don't have to be perfect to show up as your true self. Being your authentic self is something people will always connect with and feel inspired by. When you are yourself and stand in your truth, you act like a magnet; authenticity is irresistible. Finally, it's important to remember that being you will make you stand out on any saturated platform, always.

HOW IT ALL BEGAN…

… I am a photographer and ran a studio, where I specialized in newborn photography, but during the pandemic in 2020, I couldn't work, so had lots of free time. I've always loved cooking, it's a real passion of mine, and I decided to start an Instagram and TikTok account dedicated to my cooking adventures. I needed the creative outlet. Initially, I wasn't really sure what I was doing, but once I gave myself permission to fully embrace the creative process and be myself, my content started going viral, first on Instagram, then soon also on TikTok.

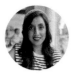

Keep it relatable

When I first started creating content, I took a broad approach, posting all kinds of recipes. But over time, I realized the importance of finding a specific niche in order to build my audience. At first, my growth felt painfully slow compared to other food creators who seemed to gain followers overnight. I'll admit, it was disappointing to be so numbers-driven in the beginning.

Experimenting with a host of different niches really honed my skills: first it was the niche of food waste, then three-ingredients-or-less recipes, then low-cost recipes, and finally air fryer recipes. All did ok, but it wasn't until I took a big step back and thought, 'what would make me want to save a recipe? What would make me want to recreate that recipe? How does this recipe relate to what I need and what I'm looking for, that things really changed.

Eventually, I learned to stop comparing my journey and instead focus on simply being myself. As I grew more comfortable in my own skin, my content improved. I focused on bringing value to my niche instead of chasing algorithms. Ironically, it was when I stopped obsessing over growth that my audience started responding. Now I know that patience and persistence pay off. Staying grounded in my purpose kept me

going until I found my footing. In fact, looking back, that relatable element is what all the niches I'd focused on previously had in common and why they'd probably done reasonably well. I'm proud of my progress and feel grateful to connect with my community in a more authentic way.

The path was slow at first, but I wouldn't change a thing. Through consistency and being true to myself, I transformed into the creator I was meant to become all along.

HOW IT ALL BEGAN...

... I'd had an Instagram account for a few years, but it wasn't until lockdown in 2020 that I made the decision to share food content rather than personal pictures. I'd recently been made redundant and, having always had a love of food, it felt like a good time to invest in myself and finally take the plunge. When I started, I didn't know exactly what I wanted to post about, I didn't have a niche, so I simply posted lots of random food content. It wasn't until I started to feel more confident in my skin that my content took off and began to go viral in 2022. Things haven't stopped since then.

HOW TO STOP PUTTING YOUR DREAMS LAST

Are you eager to make your food famous but notice yourself procrastinating rather than pursuing your dreams head on? Mindset blocks and other obstacles often get in the way of us doing the one thing we want to do more than anything in the world. So, let's break down some of the biggest hurdles holding you back from sharing your food online, and find ways to tackle them once and for all.

COMPARISON

It's in our nature to compare ourselves to idealized versions of creatives ten steps ahead of us. However, doing so is rather toxic and incredibly unhelpful, making us feel 'less than' all the time, so it's an important habit to drop when working towards establishing an online presence. If you feel yourself falling into the comparison trap, why not mute those accounts that are especially triggering, and remind yourself that you're comparing your start to their middle or end. If the urge to compare is too strong, look back at your earlier food content and celebrate how far you've come on your creative journey. Now that's a comparison strategy worth getting behind!

FEAR OF FAILURE

I'll be the first to admit that it isn't fun when you put your heart and soul into your food content, only for it to fall flat. But the truth is, it happens to all of us. Just as Alessandro (@_spicymoustache_ page 22) outlined so beautifully, failure is part of the process of sharing your food online, so why not reframe it as an amazing learning opportunity that will empower you to improve? I appreciate that it's easier said than done, but facing your fear of failure head on is the only way to overcome it.

TIME MANAGEMENT

Your dream of food fame can't come true if you don't make time for content creation. Therefore, it's paramount that you block out time in your calendar to capture your food photos and videos. Planning your shoots can also stop you from procrastinating, avoid feelings of overwhelm, and provide you with ample time to create your chosen food content. And remember, sometimes less can be more – just one piece of content can have a major impact on your reach, growth and engagement, so do what you can and see what happens!

PERFECTIONISM

Do you feel that your cooking isn't good enough, that your camera skills aren't good enough, that you're not good enough? It's completely understandable to want to be the best version of yourself and share content that's close to perfect. But the reality is, perfection does not exist and, moreover, most of the time it isn't what the world wants to see. What is needed is something more akin to the principles of wabi sabi – the perfectly imperfect: food content that's beautiful because it's authentic, delicious and real.

TIKTOK
@orchidsnsweettea_
67.2K

INSTAGRAM
@orchidsnsweettea_
352K

YOUTUBE
@orchidssweettea
2.1K

Start with the end in mind

There isn't a set structure to creating stand-out reels or TikToks, and there's always space for creative exploration and expression. That said, my husband and I generally start our recipe videos with the final dish as our opening shot. Occasionally, we use a droolworthy clip from the middle section of our video as the opener, but more often than not we start with the finished dish because sharing it at the beginning is the perfect 'hook'.

Catching people's attention is paramount and that 'hook' moment is an essential part of getting noticed on busy platforms like Instagram and TikTok. A hook also sets the scene for what your short-form recipe video is going to be about and gives people a glimpse of the story you're going to tell. It makes them curious to find out how you got to that final delectable dish.

Honestly, we didn't know what our style of recipe videos would be until we experimented with a few different formats. We film using multiple cameras, to provide us with lots of different angles and footage of the completed dish, which in turn gives us more scope to play around as we edit our video. It took heaps of trial and error, as well as a solid understanding of what resonates most with our audience, before we settled on the current format.

So, our advice to any food creator is to experiment and see what your audience loves most. Then use that structural template for all your recipe videos, whilst ensuring you keep it fresh and exciting too!

HOW IT ALL BEGAN…

… I started my blog and social media accounts in 2016, sharing Southern- and Jamaican-inspired comfort food recipes with a healthy twist. I moved into blogging full-time in 2018, but never really managed to grow my audience beyond 10K followers on social media. Then 2020 and the Black Lives Matter movement happened. Lots of bigger food bloggers shared my content and I grew to over 30K followers on Instagram alone in just a few months. Things quickly tapered off though, and it wasn't until the summer of 2022, with the introduction of Instagram Reels and TikTok, that I experienced noteworthy growth again. My account, which I now run together with my husband, gained over 60K followers on TikTok and more than 300K followers on Instagram in the space of just one year. I attribute this 100 per cent to our commitment to creating the best possible short-form video content we can!

126

INSTAGRAM
@shivesh17
2.1M

YOUTUBE
@BakeWithShivesh
1.53M

You are more than your food

I've always believed that people connect with people, and that this principle forms the backbone of long-lasting relationships on social media as well as in life. I was mindful of this fact quite early on in my food content creator journey, but especially when I started to take my Instagram more seriously.

Even though a large portion of my followers are there for my baking recipes, I sensed that sharing content beyond food could strengthen our connection further. Therefore, I decided to step in front of the camera and started sharing different areas of my life: my college days, my family life, my travels... I always let my community know what was going on.

There's so much content on social media platforms that it's really easy to be overlooked. People might find your recipe, watch your reel, and then move on, but if they feel a connection to you they'll stay. Now when I share non-baking content, my core audience still engage because it's come through me and we have a connection.

I also think that audiences on social media are evolving. Now, online communities are looking for a 360-degree experience that allows you, the food creative, to show different aspects of your personality. I love sharing more than just my baking recipes because it keeps content creation exciting and challenging. In addition, it's also made a lot of business sense – I've not just had paid partnership opportunities with brands within the food space, but also travel boards, fashion brands, pet product companies and more! To grow, share your recipes; to retain your audience, share more of you!

HOW IT ALL BEGAN...

... I grew up watching my grandmother and mother bake, and started baking myself from quite a young age. Then, in 2015, when I was at college, I decided to start sharing images on Instagram, which included images of my bakes. They got a lot of traction, with people asking for my recipes. I'd often email these through individually, but soon realized it wasn't sustainable and consequently started my baking blog in 2016. In the same year, I got more serious about my food content, and Instagram featured me on their account. As a result, I went from 15K to 30K followers overnight – a big deal at the time! Shortly afterwards, I got my first paid brand deal and was featured in a newspaper; I haven't looked back since.

Simplicity scales

Even though Instagram's algorithms have changed many times since I started out, I've always enjoyed steady growth. In the beginning, my recipes would often get reposted by bigger accounts, and once Reels were introduced, quite a few of my recipes went viral.

Posting consistently from the outset certainly helped, but over the years I've also taken longer breaks and still been able to grow my community month on month, year on year.

I think the formula to my food's success online has been to share simple recipes that still have a real pop of flavour. Some recipes out there are quick and easy, but they also taste quick and easy. I know mine don't! I often get comments from my followers who say that they love how tasty my recipes look, and indeed are, even though they're really straightforward to throw together.

In addition, I've been told that I'm able to reduce a recipe down to its core essentials, which my community deeply appreciates. I'm also able to exclude any unnecessary ingredients and keep instructions clear and to the point. No one has time to read long and complicated recipes that have hundreds of steps, especially not my audience of busy mums! They don't want all the bells and whistles, just simple recipes that work, and I always deliver on that front.

It really boils down to knowing your audience and what they're looking for from food content creators, and then catering to that – but also, what's the point of sharing your food online if it's not flavourful and realistic? Growing followers when your recipes don't make sense is really hard, so be sure to keep the food and its instructions clear and simple.

HOW IT ALL BEGAN...

... I started my Instagram page on a whim in October 2017. I was weaning my son Zayne and had initially shared the meals I was making on a personal social media account, but, naturally, no one really cared what my child was eating – why would they? So instead, I decided to open a social media account where I could share with people who did care about baby-led weaning recipes and who could benefit from the content I was making. This spur of the moment decision allowed me to grow my audience to over 300K and led to not one but two cookbook deals!

THE INTERNET'S FAVOURITE FOODS

You can find success with any food content, whether your niche is all about baking bread like Maurizio's (@maurizio, page 84) or vegan bakes like Christina's (@addictedtodates, page 30). As long as you follow the principles outlined in this book, your food is bound to become famous.

That said, there are a few dishes that always seem to hit the mark and perform well all day, every day. So, if you're looking to grow an online food community that little bit faster than everyone else, consider including these dishes on your social media feed!

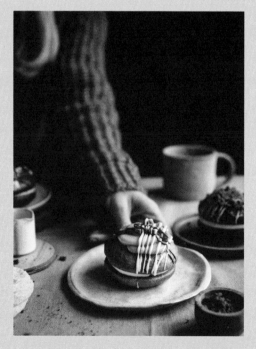

Sweet bakes and treats

The internet adores a gorgeously glazed doughnut, a crunchy chocolate chip cookie, and a perfectly baked banana bread (of course!). Though, to be honest, anything that's sweet, sugary and fresh out of the oven gets people overexcited and desperately wanting more. It's for this reason that food content creators like Jessie (@jessie.bakes.cakes, page 136) often outperform other foodie accounts both on TikTok and Instagram.

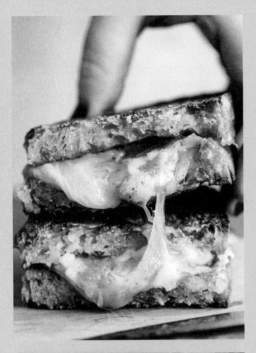

Extra cheesy

Who on earth can resist a perfectly executed cheese pull? Not many people, if the performance and popularity of cheesy pizzas and extra cheesy toasties are anything to go by. Cheese is notoriously hard to photograph and film, but once you get it right, it will pay off.

Delicious dips

I don't know what it is about dips, but they always perform remarkably well on social media. Maybe it's the creamy texture, or the winning shot where you sink a piece of bread into the dip, or the fact that they are so simple and easy to throw together. Think a chunky guacamole, a classic white bean dip, a creamy (beetroot) hummus, or a silky whipped feta – whatever the ingredients, people love a dip!

Pasta! Pasta! Pasta!

I've never met a pasta I didn't like, and neither has the online food community, it seems. Pasta is the ultimate comfort food and, hence, a firm favourite online; it's versatile, familiar, delicious, and something the whole family can enjoy. No wonder it's always a hit on TikTok and Instagram.

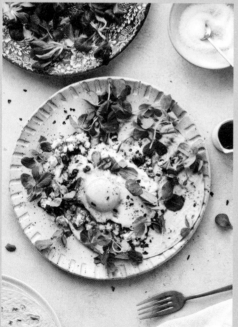

Sunny side up

Eggs are another firm favourite on the internet, especially fried eggs with an extra yellow, runny yolk. Eggs have been at the centre of quite a few food trends over the years, including the crispy feta fried egg version shown here. If you can think of an innovative egg recipe that's both beautiful and delicious, you'll amass an audience in no time!

'chunky guacamole...
or a silky whipped
feta – whatever the
ingredients, people
love a dip!'

TIKTOK
@jessiebakescakes
24.9K

INSTAGRAM
@jessie.bakes.cakes
145K

Sugar rush!

Once I made the decision to become a full-time food content creator and post consistently, my growth was strong and steady. Then I shared a reel of some Halloween brownies; it went viral, amassing more than 1 million views in a short amount of time, and consequently I grew my audience really fast from there onwards.

It made me realize a few things. Firstly, how much people love baking content and the more indulgent it is the better! Bakes are so aesthetically pleasing and showcasing the layers, textures and gooey goodness is what excites my audience. Secondly, it opened my eyes to the fact that it's so important to post seasonal baking content at just the right time. It makes all the difference and really helps your content stand out.

Finally, that viral moment showed me that in order to do well as a baking content creator, you need to lean into what your audience loves. From that and subsequent viral moments, I know my audience really likes seasonal baking content. Furthermore, after reviewing my insights dashboard on Instagram, I also discovered that my community is completely cookie obsessed! So now I try to weave a cookie recipe into my content plan at least once a month to keep my audience engaged and their cookie cravings satisfied.

Because everyone loves a sugar rush, there is a lot of baking and dessert content on both Instagram and TikTok, but if you have a genuine passion for baking and are willing to put your business hat on, be consistent and learn what content your audience loves, you're bound to find success.

HOW IT ALL BEGAN...

... In 2011, when I was still at university, I started an Instagram account all about baking. Instagram was still in its infancy, and none of us knew what was even possible – as a result, my content wasn't very professional looking and I never really grew beyond a couple of hundred followers. Then I graduated, got a full-time job and stopped posting altogether. But in 2020, I used lockdown as a time to reflect on what I wanted out of life and realized I felt passionate about baking. I decided to dedicate every minute to content creation, growing over 100K followers in just three years! I now work with brands and create baking content full-time, and am a published author of my first cookbook *Chocolate Overload!*

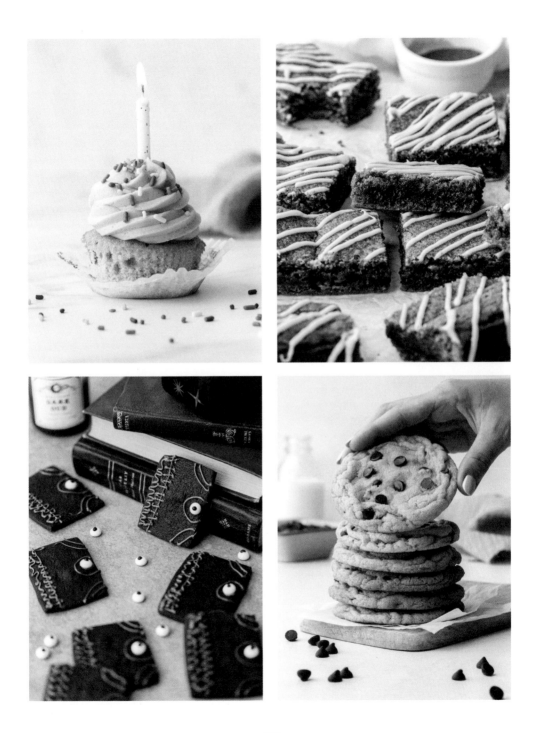

Take your time

One very common piece of advice is to 'just start' and, depending on where you are in your creative journey, that might be just what you need to hear. However, in contrast, I decided to spend a year developing my ideas before sharing anything publicly. It may not sound very exciting, but it can be extremely lucrative to first become clear with exactly what you want to share, and how you want to position yourself in the food space.

We all come with our own cocktail of talents and shortcomings, get familiar with yours. Lean into the parts of the process that excite you most, and build your content around that. As my background is in film and video, I decided to put extra care into my video production value. For me, this meant multiple test shoots, ironing out any pain points in the production process, and writing a backlog of material that could be used in voiceovers. All the while actively consuming a huge amount of content on social media, noticing things I could incorporate, and things I'd rather do differently.

This way, not only are you more likely to find and fill a gap in the market, but you'll be less affected by the unavoidable ups and downs in engagement. Your energy can be better spent on exploring your style, and further developing your purpose.

I sincerely believe that a deep consideration and understanding of your purpose will result in work that resonates with people beyond the typical scroll session. I see content creation, at its core, as a service industry – we need to be far more concerned with what we are offering the viewer, than what they can offer us. So, take your time.

HOW IT ALL BEGAN...

... I posted my first video in January 2021. Having been a freelance filmmaker and avid cook for years, the pandemic served as a catalyst to launch this project I'd been quietly working on – to share videos within the food space in a way that felt authentic to me, with the hope of bringing a measure of calm to the scroll. My first few videos got tens of thousands of views on TikTok, and a large account discovered and featured me on Instagram very early on, which allowed me to grow to over 10K followers in the first month. There have been peaks and valleys along the way, and surely many more to come.

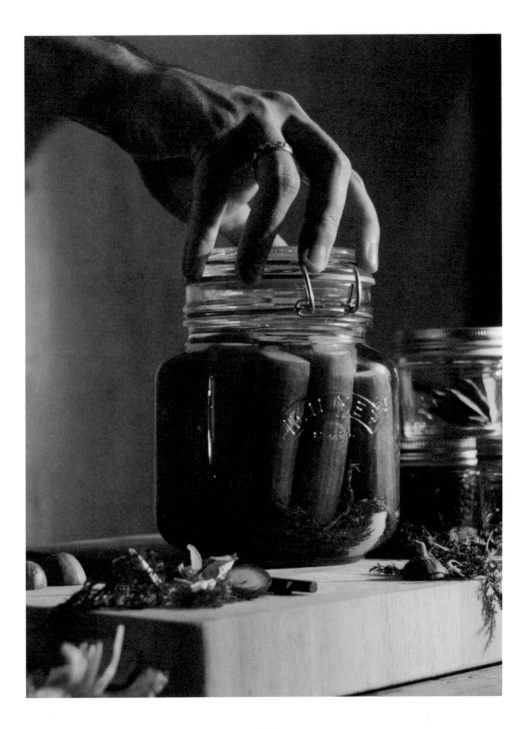

TIKTOK
@pigtoriasecret
492.7K

INSTAGRAM
@pigtoriasecret
351K

For giggles

The first social media account I started whilst I was at university failed miserably. I wasn't thoughtful, just posted random stuff I liked, but I quickly realized that laissez-faire approach wasn't going to get me to where I wanted to be. Having learned from the shortcomings of my first account, I understood that people use social media to relax, to feel good, to seek comfort. I knew that if I wanted to grow, I needed to offer valuable content that tapped into these emotions. I also knew that the quickest route to those feel-good vibes was humour. And what came easiest to me in my quest to make people laugh was to laugh at myself!

I grew up in an Asian household where I simply couldn't meet the epitome of Asian values. So, instead of trying to fit a square peg into a round hole, I embraced all my imperfections with a good dose of humour – in life and online.

My tongue-in-cheek approach has always allowed me to stand out, to be different and to grab people's attention, and I simply applied that same way of being to my social media channels. There, I acknowledge wholeheartedly that I'm flawed; I highlight without shame that I'm not a professional chef and I candidly admit that I don't have it all figured out. That willingness not to take myself too seriously, mixed in with a good dose of giggles and lots of hard work, expedited my growth both on TikTok and Instagram. It's been a huge part of my success formula.

Going viral on social media isn't an accident. You just need to remember that people want to feel something when they are on Instagram or TikTok. And you can make them feel happy and entertained by tapping into your humorous side!

HOW IT ALL BEGAN...

... Following the failure of my first account, I understood that I needed to offer value. So when I opened a new account, Pigtoria Secret, I was clearer from the outset what my intentions were and, consequently, the very first video I posted on TikTok went viral. I started the account at a pivotal point in my life, when the world was just coming out of the pandemic and I was struggling to find a job after graduating, so I decided to go all in and see if I could make it work as a food content creator.

140

'...willingness not to take myself too seriously, mixed in with a good dose of giggles and lots of hard work, expedited my growth...'

THE V WORD: VALUE

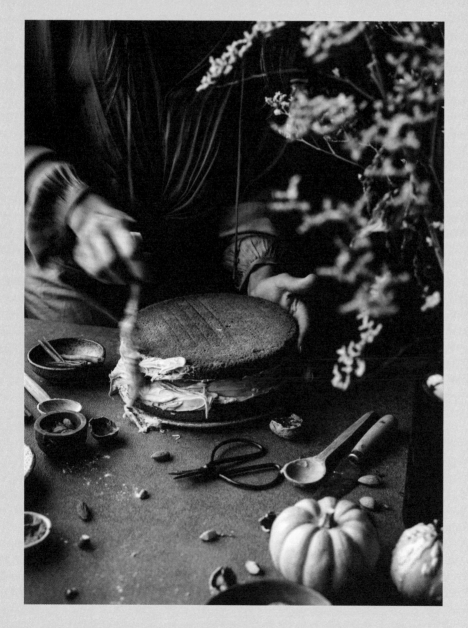

'Value' is the underlying component that should form part of each piece of content you share online. You want to ensure that every single time someone engages with your content, you have a positive impact on them. That's a big task, but it can be done. And here's how...

EDUCATE

Creators such as Steph (@stillbusybaking, page 144) and Maurizio (@maurizio, page 84) exemplify how to use your platform to educate your audience and make them feel like they gained helpful knowledge by engaging with your food content. They achieve this by providing a lot of how-to content, sharing practical tips and tricks and being open and available to answer any questions their audience might have.

Generally speaking, recipe content is educational, as are behind-the-scenes clips, infographics, live Q&A sessions, content that gives historical or cultural context, and so on. Educational content is what I focus on on most of my social media channels, and it has been key to my audience growth.

ENTERTAIN

Traditionally, we'd turn on our TV for entertainment, but more and more of us are using social media to get our fix.

Entertaining your audience on Instagram and TikTok can involve making them laugh, which is what Pierluigi (@chef__pier, page 112) does so well. I would also argue that the food content created by Andrew (@thenarddogcooks, page 20) is highly entertaining because his videos almost feel like mini cooking-shows filled with stories.

INSPIRE

There's a beautiful quote by Maya Angelou that goes: '...people will forget what you said, people will forget what you did, but people will never forget how you made them feel.'

Evoking a feeling that makes people aspire for more is at the core of why inspirational content is so hugely impactful and unbelievably popular. Lucia (@lucia_carniel_lultimafetta, page 78) is a great example of someone whose food content is really inspiring. The question is, could inspiration be the value that you offer your audience?

TIKTOK
@stephcarr.5
673K

INSTAGRAM
@stillbusybaking
262K

YOUTUBE
@stillbusybaking
458K

Put your teaching hat on

I understood quite early on that people are looking for value when they turn to TikTok or Instagram. That value can be entertainment, inspiration, laughter or education; I decided to focus on the latter because I absolutely wanted to grow doing something I truly love. There's little point jumping on a trend or a growth strategy you're not passionate about, as it will be very hard to sustain your account long term.

I tried sharing a lot of different baking tutorials but have found a sweet spot in creating baking content for beginners; my bakes are therefore both achievable and approachable – in short, anyone can do them. This means that people experience an instant win when they recreate my bakes or cake decorations. This in turn makes my baking tutorials very shareable, which has allowed me to reach more people and enabled my food content to go viral.

My focus is always on creating the most helpful and valuable learning experience in the least amount of time. I try to keep my baking tutorial videos between 20 and 50 seconds, no more. Keeping within that time limit can be really hard, but I aim to give people enough detail that they can get started right away with the bakes they are most excited about. And to ensure they have the best learning experience possible, I share longer, more detailed content on my blog and YouTube channel.

If you decide that you want to put your teaching hat on and share what you know online, be sure to develop your very own approach to teaching. Mimicking other creators will make building your own community that much harder. Remember, there is always space for someone new, who is doing things their own unique way!

HOW IT ALL BEGAN...

... I got into baking from a really young age. Then, at university, I became the unofficial baker in my friendship group and always baked a birthday cake for my basketball team mates too, allowing me to further hone my skills. As my parents weren't too keen on sweet treats, I learned most of my baking skills from the internet, and when the pandemic hit in 2020, I thought it was a great time to not only improve my cake decorating skills, but also play it forward and share what I'd learned with others. Through consistently sharing my baking knowledge, my Instagram, YouTube channel, blog and TikToks gradually grew to where they are today.

'...there is always space for someone new, who is doing things their own unique way!'

TIKTOK
@vernahungrybanana
487.3K

INSTAGRAM
@vernahungrybanana
382K

It's always been about you

When you start a food-related social media account, you need to have a clear focus. Once your distinct niche has been established, once you're seen as the expert, once your page becomes synonymous with creating delicious recipes, then you can share more than just food, including more content with you in it!

I'm not a trained chef and I don't invent recipes per se. I feel as though my recipes are good, but they aren't special – you can easily find similar recipes on the internet. Ultimately, it's the fact that I attach my personality to my recipe content that makes it different. It's what makes my content so relatable and what has helped me distinguish myself from other food creators.

It's as if the recipe content is the initial hook, the thing that catches people's attention, but it's the person behind the food that keeps people interested. So, as my page was growing, I decided to step in front of the camera and allow more than my hands to be in frame. I also started sharing more about my life, my thoughts and my opinions. After going viral in 2022, I noticed that there was an endless stream of food creators joining the scene and it started to become really saturated; the decision to show my face more prominently from 2022 was a strategic one.

The truth is, it's not hard to make food look good. But not everyone is able to put themselves out there. Plus, no one is me, and the fact of the matter is, no one is you! Featuring yourself in your food content will make you distinct and allow your authenticity to shine through. To gain traction now, it's almost a necessity.

HOW IT ALL BEGAN...

... In 2019, after managing someone else's food Instagram account for over a year, it felt like it was time to start my own page. Initially, I just shared images of restaurants I was invited to, but the account didn't grow particularly fast as there was little value added. Everything changed in 2020 when I cooked breakfast, lunch and dinner and documented each and every meal I made on both my Instagram and my TikTok accounts. Things really took off in 2022 and haven't stopped since. Though I never intended to become a full-time food content creator, somehow I did!

FOOD FOR THOUGHT

Posting content on Instagram and TikTok can sometimes feel like an emotional rollercoaster: one day you're flying high after your content has garnered lots of likes; the next you feel down in the dumps because something you posted completely tanked. We've all been there, and considering how deeply we care about the food content we create and how vulnerable it makes us to share it publicly, it's not surprising we feel attached to its reception. So how best to cope with the emotional intensity of sharing your food content on social media?

TIME LIMIT

When you share a piece of content online, it's perfectly normal – and even advisable – to stay online to respond to comments and questions that may arise from your community. But, in order to not get too attached to whether your content is resonating or not, close down the app within a set timeframe, ideally within 30 minutes.

Remember, you can control what you put out into the world, but you can't control how it's received, no matter how often you check your post's performance.

CREATION OVER CONSUMPTION

A positive mindset and good mental health can be cultivated through action. It is for this very reason that I'd always advocate focusing on creating food content over consuming it. The former will allow you to channel your ideas into something beautiful and delicious that can bring you closer towards your goal of food fame. The latter – though fun and even somewhat addictive – is merely a passive activity that won't contribute to growing your audience online and, when done in excess, can seriously harm your mental health.

USE IT AS A LEARNING OPPORTUNITY

Please know that every single creator featured in this book has had their fair share of 'failed' social media posts. I understand that it can feel heart-wrenching, but it is an inevitable part of the learning process and a really important stepping stone on your journey to food fame.

It's tempting to blame those pesky algorithms when your food content flops, but doing so pulls the centre of control away from you and straight into the hands of Mark Zuckerberg and co, which can feel really disempowering. In contrast, if you see the reason behind a flopped piece of content as something you can adjust, improve and avoid going forward, it puts you right back into the driving seat. How empowering is that!

MUTE CONTENT THAT'S TRIGGERING

Do you compare yourself to other food creators online? My guess is you do, because it's human nature to try and establish where we sit in comparison to others. However, if doing so creates a sense of inadequacy or makes you feel disheartened, it's important to shift gears. I suggest muting or unfollowing anyone who makes you feel like you're not good enough, no matter how much you like their content. I promise you'll feel better for it.

TAKE A BREAK

Sometimes, no matter how hard we try, it seems impossible to disentangle our self-worth from how well our content performs online. In those instances, when you notice yourself slipping into a state of despair, take a break from social media. Then use the time it frees up to journal, go for a walk, spend time with family, cook ... anything that will help lift your spirits and reinvigorate you.

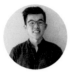

Uniquely scrumptious

I started cooking for myself when I was at university, and I noticed that I really enjoyed experimenting in the kitchen, coming up with recipe ideas and cooking food without knowing quite what the end result would be. Sometimes I produced something that tasted nice, sometimes it didn't taste nice at all, but both experiences were valuable to me, as I was able to better understand what flavour combinations and techniques worked, and what clearly didn't.

Creating something uniquely scrumptious has helped me to stand out, though initially developing weird flavour combinations was primarily about wanting to create something I myself was excited to try. I love the idea of developing a recipe you can't find anywhere in the world, and I think pushing the boundaries of flavour isn't something many people do, so it definitely helped get eyeballs on my content.

To experience real growth, I've had to start thinking more about my audience and what resonates with them as well as what I like to eat. It's about finding that sweet spot. If you don't take your audience into account, growth will be hard. In turn, if you want to please your audience but don't allow your curiosity to thrive, you'll burn out.

A rule that I've heard people speaking about is this: 80 per cent of a recipe should be familiar to your audience and the remaining 20 per cent should include an attention-catching twist. In addition, there's a balance to be struck between how weird and wonderful your recipe is and how easy it feels to your audience to recreate it. If it's too complicated, it will put people off. If it's not intriguing enough, people will scroll past.

Creating food content that is uniquely scrumptious is a great way to keep things interesting for you, a fabulous way to attract people's attention and an amazing way to stand out. It's a win-win formula!

HOW IT ALL BEGAN...

... I started a food blog in 2016, writing recipes, exploring food culture and covering food history. A few years later I created an Instagram account that was more personal and, consequently, growth was slow. It wasn't until 2020 and the rise of short-form video content that I grew, as it allowed me to present my recipes in a more appealing way. I continue to work full-time in the food space as a food content creator, recipe developer, food writer and food photographer.

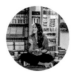

TIKTOK
@fridgelovebook
3.6K

INSTAGRAM
@hellonutritarian
246K

YOUTUBE
@hellonutritarian
9.3K

Think outside the box

When I started sharing images of my food prep on Instagram, I got so many questions right off the bat. People wanted to know how I was prepping and storing produce, and how I managed to keep things fresher for longer. My food content posts were instant conversation starters and community builders, which helped tremendously with growth.

It's easy to look at what other people are doing within the food space and feel that you have to follow suit, but the truth is, you don't. In fact, you shouldn't, if you want to stand out! I no longer share recipes, even though many food content creators obviously do. Instead, my content marries two popular niches – food and organization. I think it's my ability to think outside the box and offer my community something a bit different that's allowed me to grow my audience.

Because I seldom step in front of the camera, I lean heavily into sharing short-form videos so that they connect with people. It's the focus on fun and inspiration that's propelled people to share my content, which has extended my reach and expedited my growth online.

If you want to share food content, but want to approach it in a novel way too, think about what your community of foodies would like to see apart from recipes. Consider combining another trending niche with food, or provide resources, tips or inspiration on topics that relate to food, but aren't strictly recipe-based content. In other words, why not think outside the box too when it comes to sharing your food online?

Then package your content in short, fun video clips. Make it beautiful, enticing and inspiring. Keep posting – and don't give up because your time will come!

HOW IT ALL BEGAN...

... I started an Instagram account in 2013 to sell my jewellery online, and not long afterwards I pivoted to sharing content directed at mums. It was on my mummy blog that I posted meal prep ideas for the first time in 2016. The response I had was unlike anything I'd ever experienced. So, in 2017, I changed my Instagram handle to @hellonutritarian, started sharing the fridge content I'd previously only posted on my blog, and grew my audience very quickly from there. Things exploded during the pandemic, and the traction I gained allowed me to get a book deal, work with brands and increase my revenue.

Index

Acknowledgements

Everything I create, including this book right here, is fuelled by the love from the man and boy in my life, Santiago and Gabriel. You are and always will be the source of it all.

An enormous thank you to Christina, Beatriz and Suzanne for making TLP HQ the success that it is and always having my back! A special shout out to Eleni for tirelessly working with me behind-the-scenes on this book and giving all the incredible contributors a safe place to ask lots of questions.

Thanks to my family for being you. Love ya!

To Andrew, my patient editor at White Lion, for choosing me and believing in me to bring this gorgeous idea to life! You have the patience of a saint and I know working with a fierce and fiery creative like me is a trip and a half!

A huge and massive thank you to the insanely talented contributors who shared their experiences, their insights, their images and their creativity so generously with the readers. This book would not be the source of inspiration and knowledge it is without you!

And finally, to my students, mentees, clients and Instagram fam: your questions shaped the direction of this book, your curiosity made me a more skilled educator, your requests allowed me to become a better photographer and stylist, and your support for my first book, *Creative Food Photography* made THIS right here possible. Thank you so much from the bottom of my heart.

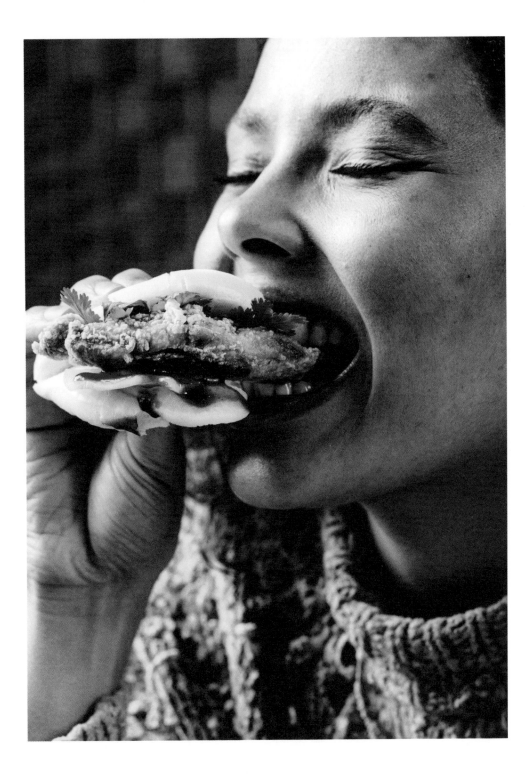

About the author

Kimberly Espinel is an award-winning London-based food photographer, stylist, content creator, creative business mentor and educator. She has taught food photography, food content creation and food styling to thousands of students from around the world. Kimberly runs a successful food photography business and is known for her light and shadow play, her bold use of colour, her warm and encouraging teaching style, and her playful approach to composition and styling.

Kimberly hosts the Eat Capture Share podcast and is the author of the Amazon best-selling book *Creative Food Photography* as well as *The Playbook. How To Make Your Food Famous* is Kimberly's latest book.

Quarto

First published in 2024 by White Lion Publishing
an imprint of The Quarto Group.
One Triptych Place, London, SE1 9SH
United Kingdom
T (0)20 7700 6700
www.Quarto.com

ISBN 978-0-7112-9381-6
EBOOK ISBN 978-0-7112-9383-0

10 9 8 7 6 5 4 3 2 1

Book Designer: Studio Polka
Commissioning Editor: Andrew Roff
Editor: Charlotte Frost
Editorial Director: Jenny Barr
Junior Designer: Daisy Woods
Publisher: Jessica Axe
Senior Designer: Renata Latipova
Senior Production Controller: Rohana Yusof

Printed in China